SCOTLAND SCHOOL
— FOR —
VETERANS' CHILDREN

SCOTLAND SCHOOL
—— FOR ——
VETERANS' CHILDREN

An Enduring Legacy

Sarah Bair

Published by The History Press
Charleston, SC
www.historypress.net

Copyright © 2017 by Sarah Bair
All rights reserved

Back cover: Aerial view of Scotland School, March 13, 1997. *Photo by N. Joseph Ketterer.*

First published 2017

Manufactured in the United States

ISBN 9781467119306

Library of Congress Control Number: 2016961489

Notice: The information in this book is true and complete to the best of our knowledge. It is offered without guarantee on the part of the author or The History Press. The author and The History Press disclaim all liability in connection with the use of this book.

All rights reserved. No part of this book may be reproduced or transmitted in any form whatsoever without prior written permission from the publisher except in the case of brief quotations embodied in critical articles and reviews.

Contents

Foreword, by Frank Frame	7
Alumni Note by James A. Lowe ('70) and Sally Sheaffer ('65)	11
Acknowledgements	13
Introduction	15
1. Historical Overview	19
2. Scotland "Kids"	41
3. Discipline, Military Tradition and Work	61
4. The School Experience	81
5. Life Outside the Classroom	101
6. Fight for Survival	123
Epilogue	139
Notes	143
Index	153
About the Author	157

Foreword

I was first introduced to the Scotland School for Veterans' Children (SSVC) in the spring of 1967. My wife, Loretta; my one-and-a-half-year-old son, Sean; and I flew from Fort Myers, Florida, to Harrisburg, Pennsylvania, arriving in a snowstorm. Dr. Dale Reinecker, superintendent of SSVC, interviewed me for a teaching and coaching position. Needless to say, I received the offer of employment, and in August of the same year, I began my forty-five-plus-year relationship with the school. Little did I realize at the time the effect this relationship would have not only on my life but also on Loretta's and Sean's. I would go on to serve as teacher, coach, curriculum director, academic principal, assistant superintendent and superintendent. I also served as founder, president and executive director of the Foundation for the Scotland School for Veterans' Children, a nonprofit we created in 1996 to increase financial support for our school. Given my experience with this residential school and its students and staff, whom I came to love as family, I am extremely humbled and immensely proud to have been asked to write this foreword.

In the beginning, Scotland was known as the Pennsylvania Soldiers' Orphans' Industrial School. The idea for the creation of the school is credited to a very caring and farsighted state leader, Governor Andrew Curtin, as a result of the Civil War. This war killed, maimed and psychologically damaged many of the brave soldiers who fought in it. Therefore, there were many struggling families as a result of men being unable to provide the essentials needed for a family to survive. Although Pennsylvania had many

existing orphanages, it was Governor Curtin's vision to create a statewide system for orphan care that would be funded and administered by the state government. After receiving an initial donation from the Pennsylvania Railroad Company, Curtin was able to convince the legislature to provide funding to several institutions for the care and education of Civil War orphans. Although funded, it was done insufficiently, which proved to be a thread woven throughout the school's history.

In 1895, this system of orphan care was consolidated under one school in Scotland, Pennsylvania, but the Pennsylvania Soldiers' Orphans' Industrial School was always much more than a school. It served as a home providing food, shelter, clothing and medical care in addition to vocational, physical, moral and military training. The original mission specifically stated that the school was "to provide care and protection to any remaining Civil War orphans in Pennsylvania and to give them the academic and industrial training needed to be disciplined, patriotic, and productive citizens." One can easily deduce that this mission was met and exceeded. In 1928, long after Civil War orphans had gone, the school received official accreditation from the state.

In 2009, the school, by then known as the Scotland School for Veterans' Children, functioned with a mission "to motivate its students to develop lifelong learning skills and to challenge them to achieve their full potential as responsible citizens in a global society by providing a high-quality educational environment within a homelike, caring, and nurturing residential community." Although this mission was clearly being fulfilled, the school was selected by Governor Edward Rendell and his supporters in the state legislature to be closed as a result of a national and statewide budget crisis. Many of us supporting the school—students, parents, alumni, staff and friends—considered this decision shortsighted and uncaring. However, using the arguments that operational costs were too expensive, that students were no longer orphans and that few were veterans' children, they succeeded in their move for closure of this venerable institution. The children were sent home, mostly to inner-city Philadelphia, with many returning to schools and neighborhoods from which their parents, guardians or grandparents had hoped to remove them.

Ultimately, it is the years in between the "beginning" and the "end" of the school that really matter. They mattered for thousands of graduates and hundreds of staff who "cared for the very successful children." How did we measure success? We measured it by the thousands of students who graduated and became productive citizens and responsible mothers

Foreword

and fathers; by all those who became gainfully employed as doctors, lawyers, business leaders and civil servants, including a treasurer for the commonwealth of Pennsylvania; by those who became law enforcement officers, nurses, research analysts and educators, including an internationally recognized education research specialist, who serves as an associate professor at the University of Pennsylvania while directing his own education research firm; and by all those who served in the armed forces, including a captain in the U.S. Navy charged with oversight of a research study of suicide in the navy and a colonel in the U.S. Army charged with the oversight of a research study on malaria.

SSVC graduates may be found with degrees from all the Pennsylvania state university system locations, the U.S. Military Academy, Howard, Morehouse, Columbia, the Wharton School of Business, the University of Michigan, Temple University, the University of Iowa, the University of Connecticut and the University of Pennsylvania. In its final years, the school was matriculating 90 percent of its students to institutions of higher education with a high degree of success, due in part to funding provided by the Foundation for SSVC and a follow-up program provided by the school.

Herein lies the "real story" of the school, its students and staff. The author, Sarah Bair, through countless hours of research and similar hours of personal interviews with students, staff and friends of the school, has captured the essence of what the school was and still is in the hearts and minds of those who are part of the Scotland family.

Sarah addresses the common threads that weave through the fabric of the school throughout its 114-year history. These threads include, but are not limited to, ongoing struggles to keep the school adequately funded; changing eligibility requirements as indicated by several name changes (PSOIS, SOS and SSVC); students' feelings about the school and their placement there; Scotland as a home and family; approaches and students' reactions to structure and discipline (some may say "punishment"); curriculum and school experiences; extracurricular activities and opportunities for leisure time and play; and the last and strongest thread, "the commitment to care for veterans' children." At SSVC we were, are, and always will be "FAMILY!" As such, we concur with the old African adage, "It takes a village to raise a successful child." Our school was that village.

Thanks to you, Sarah Bair, for truly capturing the very heart and soul of SSVC and putting it into print for posterity.

—Frank Frame, former SSVC superintendent

Alumni Note

We are so very grateful to Sarah Bair for writing a concise, yet all-encompassing book about the history of our beloved Scotland. Sarah spent an incredible amount of time researching the contents of her book, and she nails it in every chapter. We believe you will enjoy each page of this volume. Alumni, do you think you know a lot about Scotland? Most of you probably believe you know a fair amount of information about the school. So did we until we read Sarah's book and found so much more exciting material from the inception of Scotland in the 1890s through the closing in 2009.

Many readers will recognize alumni who shared their stories with Sarah as well as faculty and staff who added their perspectives, many times with amusement, on the growth of our school. Former students, read about your classmates and those who have gone before and those who came after, all within the context of different aspects of our life at Scotland. Readers will learn how Scotland "kids" experienced home life, discipline, military tradition, work and leisure along with school life, extracurricular activities and relationships with teachers and coaches.

Alumni will come away with a greater sense of pride for all we accomplished while students at Scotland and a greater appreciation for the faculty, staff and house parents who encouraged us and provided support every step of the way. This book is all about our family and well worth your time, so sit back, relax and enjoy!

—James A. Lowe, class of 1970, and Sally Sheaffer, class of 1965

Acknowledgements

I am grateful to many people who supported me while researching and writing this book. In 2008, when I began initial research on the Scotland School for Veterans' Children (SSVC), Ron Grandel, Scotland's final superintendent, warmly welcomed me to campus and introduced me to Jim Lowe '70, who served as director of student affairs at that time. As a former SSVC student, teacher, coach, administrator and longtime president of the Scotland Alumni Association, Jim provided me my first window into Scotland's history and guided me into the school community. In addition to providing access to the SSVC museum, he invited me to alumni functions and helped me sort through school documents. I also have Jim to thank for introducing me to Sally Sheaffer '65, who served as secretary of the alumni association when I began this project. I quickly came to appreciate Sally's organizational skills, good humor and unfailing kindness. Sally contacted people on my behalf, set up interviews, and provided resources whenever she could. From Jim and Sally, I learned a great deal about the heart of Scotland School.

In addition to their help, I received generous support from former SSVC superintendent Frank Frame, who not only agreed to a lengthy interview but also talked informally with me on numerous occasions and patiently answered countless questions about the Scotland School. In addition, Frank and Sally spearheaded an invaluable effort to gather photographs for the book. Susanne Beckner Pinsky '63, Betsy Beckner Hendricks '64, Jim Lowe '70 and Annette Portner (wife of David Portner '69) also helped with this

Acknowledgements

process. I owe a special debt of gratitude to Hector Robinson '73 for his expertise with formatting and scanning many of the images.

I am enormously thankful to the many SSVC alumni who shared their stories with me in oral history interviews. Their voices and those of faculty and staff I interviewed bring Scotland to life in a way that documents alone never could. Amanda Wernicke, a 2010 graduate of Dickinson College, carefully transcribed many of the interviews, allowing me to provide excerpts in the book. In the summer of 2011, I received help from another Dickinson undergraduate student, Tom von Allmen, who, with funding made available through Dickinson College, served as my research assistant. I am especially grateful to Tom for his careful review of Scotland School newspapers in the state archives. That summer, and on many later occasions, I had the pleasure of working with the helpful staff in the Pennsylvania State Archives, where many SSVC records are housed. I am also indebted to longtime SSVC staff member Charles A. Goldstrohm and Donald P. Cooper '41, each of whom wrote historical retrospectives of the school to commemorate Scotland's 75th and 100th anniversaries. These books, written by individuals who knew and loved SSVC firsthand, served as important references for me.

Several people read drafts of the book and provided excellent feedback. These include Elizabeth Lewis, my colleague in the Educational Studies Department at Dickinson College; Murry Nelson, professor emeritus in the College of Education at Penn State University; and Jim Lowe, Sally Sheaffer and Frank Frame, who offered their perspectives as members of the Scotland family. Unless otherwise noted, all images are courtesy of the Scotland School Museum.

Finally, I would like to thank my husband, Jeff, and my three children, Sean, Ellen and Anne, for encouraging me in this project. I love them beyond measure.

Introduction

My first memories of the Scotland School for Veterans' Children date back to the early 1980s and to one exceptional 400-meter runner named Sheri Durricks ("Slim" to her friends and teammates). I ran track for Littlestown Area High School at the time, and she and I anchored our respective 1,600-meter relay teams. I cannot say that I knew Slim beyond the usual starting line small talk, but I sure did admire her running and can still conjure up images of the back of her SSVC jersey as I inevitably chased her around the track. Despite this personal interest in the girls' track team, I knew nothing, at the time, of Scotland's rich history or of what life was like for the thousands of children who had called this residential school home since it opened in 1895.

Over the years, I continued to follow Scotland athletics but still had little exposure to other aspects of the school until 2001, when I took a position in the Education Department at Wilson College in nearby Chambersburg, Pennsylvania, and had the opportunity to supervise a student teacher placed at Scotland. In this role, I visited the school regularly during the fourteen-week semester. The more time I spent observing and talking with students and staff about Scotland and its mission, the more interested I became in the school's history. A couple years later, after I had begun my current position at Dickinson College and was involved in a federally funded, professional development program for Franklin County teachers, I met Rich Richardson, a young history teacher at Scotland. Through conversations with Rich, my initial interest in the school reemerged, and I began thinking about a formal

Introduction

research project related to SSVC. In 2008, when I took my first sabbatical at Dickinson, I spent the semester in the Pennsylvania State Archives and at the Scotland Museum investigating the school's origins and early history as a home for children who had been orphaned by the Civil War. In a sadly ironic twist, the timing of my research on Scotland's beginnings coincided with events leading to the school's closing in 2009. In June of that year, Scotland alumni from around the country gathered at Scotland for their traditional alumni weekend. Knowing closure might be imminent, many people came to say goodbye and to see the campus one last time.

With encouragement from Jim Lowe, I attended this event and got my first taste of what it meant to be a member of the Scotland family. I felt privileged to share time with former students as they walked the grounds, told stories and considered the potential loss of their school and childhood home. I participated in dozens of informal conversations and conducted my first oral history interviews with twenty-three Scotland alumni, the oldest having graduated in 1941 and the youngest in 2008. I did not know at the time what would become of these interviews or exactly where my research would lead, but by the end of the weekend, I felt committed to helping preserve the school's history in some way.

In the years following that reunion, I returned to my Scotland research when I could, writing articles for academic journals and considering a book. Knowing that SSVC had no formal archive and that significant pieces of the historical record may not have been preserved, I recognized the difficulty in writing a comprehensive, chronological narrative of the school, but I continued to believe that a book about Scotland would be an important step in preserving and sharing its history. With this in mind, during my second Dickinson sabbatical in 2015, I began research, not with the intention of covering all important aspects of Scotland's history but rather with the hope that I could use school records and oral histories to capture something of its essence and spirit.

While I hope this book will be of value to the general public, especially those with an interest in education and in state and local history, I recognize that alumni, former staff and friends of the Scotland School will have a special interest in its content. The importance of honoring their memories has always been clear to me but never more so than in June 2015, when I attended an SSVC alumni gathering at the American Legion in Chambersburg. Jim Lowe introduced me and asked me to tell alumni about my plans for this book. At the end of my brief remarks, I asked for questions or comments. A gentleman I did not know stood up and expressed his hope that I would

INTRODUCTION

not "write a boring book." He went on to explain that he was less interested in reading about building construction or various policy initiatives than in getting the "real" Scotland story, by which he meant one that told what students' lives were like and what they went through at the school—good and bad alike. His comment opened the door to several other suggestions about what I might or might not include in the book. Some people urged me not to sugarcoat harsh realities at Scotland, while others expressed their desire for me to convey how the school provided a stable and loving home and saved the lives of countless children. Somewhere in the midst of these conversations, as I frantically jotted down notes on a paper placemat, I felt, as I had many times before, the full weight of responsibility. I wanted to get the story *right*, even as I understood all too clearly that there is no single story of the Scotland experience.

Over the past several years, I have come to respect and feel great affection for many people associated with the Scotland School. I spent many hours on the campus poring over old yearbooks, photographs, letters, newspaper clippings and numerous other primary documents. In the state archives, I read official annual reports and school newspapers across all eras. I interviewed and spoke to former students, teachers and staff and listened intently to many conversations. I heard people laugh out loud as they recalled antics from their Scotland days, break down in tears when talking about the school closing and express anger when describing the school's approach to discipline. I learned a great deal about the Scotland School and appreciated the warmth I experienced in the alumni community. At the same time, I write this book with full knowledge of my status outside the Scotland family. I cannot know what it felt like to grow up at Scotland or to work there. Despite my best efforts, I might have missed some critical component of the Scotland story or emphasized points viewed less significantly by insiders. This book reflects what I have learned about life at Scotland, but I recognize that others would have a different story to tell and that there are many topics I address briefly that warrant further research and, perhaps, additional books.

I have not written a chronological history. Rather, in the first chapter I provide a brief historical overview, highlighting the founding and construction of the campus, major events and key leaders from 1895 to 1991, the year when the school confronted its first threat of closure. While much of the material in this chapter will be familiar to Scotland alumni, I hope to provide new details while also offering those unfamiliar with the Scotland story a basic narrative to anchor the rest of the book. In the next four chapters,

Introduction

each of which focuses on an important aspect of life at Scotland, I provide historical context based on documentary evidence and use oral history interviews to illustrate how real people experienced different aspects of the school. As with all oral histories, they represent the speakers' memories and their understandings of events. They may not be indicative of others' experiences or interpretations. In instances where interviews are used to draw general conclusions, I corroborate them by looking for patterns within the interviews and by consulting other sources. The final chapter covers the period from 1991 to 2009 and focuses on two major battles between SSVC and the Pennsylvania state government, the last of which resulted in the closing of the school in 2009.

Finally, I want to explain my approach to referencing Scotland's name and identifying dates. As I outline in the first chapter, Scotland had three names over the course of its 114-year history. In the overview, I either use the name associated with the particular time period I am addressing or, more frequently, I simply refer to the school as Scotland. For the sake of consistency and clarity, in the remaining chapters I either use the more general Scotland or, when appropriate, SSVC. When verifiable, I use specific dates in this book, but, in some cases, the documentary evidence allowed me to narrow down an event or development or photograph only to a decade. In these cases, I made every effort to be as accurate as possible when providing a time frame. Any errors that may be uncovered are mine alone.

1
Historical Overview

On March 16, 1866, Andrew G. Curtin, Pennsylvania's Civil War governor, left his office and headed for the state capitol building to address the legislature. The war had ended almost a year earlier, but Curtin knew his state's recovery would be long and expensive. On this day, he hoped to convince reluctant legislators to continue funding his previously established Civil War orphan education program. Pointing out that it would be unconscionable to have children fending for themselves on the streets of Pennsylvania when their brave fathers had "brought us fruits of hard fighting and gained us our victories," Curtin reiterated the successful argument he had made two years before. At that time, during the heart of the war, he convinced legislators to supplement a $50,000 donation from the Pennsylvania Railroad Company to establish an orphan care and education program.[1] With this initial approval in hand, Curtin appointed a superintendent of orphan education to oversee the program and established a decentralized system that relied largely on existing childcare institutions around the state. Orphanages and schools within the system agreed to serve Civil War orphans and comply with state guidelines in return for state funding.[2] Curtin's successful follow-up appeal to the legislature in March 1866 would be repeated at regular intervals by his successors over the next three decades. During that period, the Civil War orphan program in Pennsylvania supervised a total of forty-three institutions across the state and served almost fifteen thousand children at a cost of nearly $10 million.[3] Without this system in place, the Pennsylvania

Soldiers' Orphans Industrial School (SOIS), as Scotland was originally named, would not have been established in 1895.

Legislators who approved funding for orphan care and education in 1864 believed the program would be short-lived, but a series of unanticipated enrollment extensions kept demand high for decades. By the early 1890s, with costs rising and management becoming increasingly difficult, lawmakers confronted a hard choice. They could either shut down the system, turning away eligible children, or find more efficient and cost-effective ways to continue it. Among those advocating the latter, support began to grow for the construction of a centralized industrial school that could meet the needs of Civil War orphans and then be converted to a manual training school for other destitute children once the last of the orphans had left the school. Several other states, including Ohio, Indiana, Wisconsin, Iowa and Illinois, had already established homes specifically for orphans of Civil War soldiers, but, unlike Pennsylvania, these states owned and operated the facilities directly.[4] To its credit, Pennsylvania cared for more soldiers' orphans than other states did in the same period, but the decentralized system presented its own challenges, and after three decades, many legislators hoped to find a new way to keep the state's commitment to Civil War veterans and their children.

In order to determine the feasibility of an industrial school, the commissioners of soldiers' orphan schools, who had taken over leadership of the system from the superintendent of orphan education in 1889, set up a special committee in 1892 to explore options and make a recommendation about moving forward.[5] After visiting several industrial schools around the country, the committee issued a report to the commission and the state legislature on December 15, 1892, recommending Pennsylvania build an industrial school to accommodate up to one thousand students.[6] As a result of this committee's work, Pennsylvania's Act of 1893 authorized the creation of the Pennsylvania Soldiers' Orphans' Industrial School and approved funds to build and operate the school. In addition to consolidating the system under one facility and providing a home for any remaining eligible Civil War orphans in Pennsylvania, legislators saw the school as a vehicle for developing disciplined, patriotic and productive citizens who would strengthen the state's economy.

The Act of 1893 reaffirmed admissions requirements established under previous laws and outlined admissions preferences. Parents of applicants had to have lived in Pennsylvania for five years prior to the date of application and applicants had to be under the age of fourteen. According to the law,

Historical Overview

they would be educated to the age of sixteen, but provisions allowed those students who would be fifteen or sixteen when the school opened to stay an extra two years to benefit from an industrial education. First priority for admission went to full orphans of soldiers, sailors and marines who served in the Civil War as members of Pennsylvanian commands or, having served in other commands, resided in Pennsylvania when they enlisted. Second priority went to children as described above with deceased fathers and living mothers. Children with parents who had disabilities were third priority. In the original orphan education system, veterans had to prove their disabilities stemmed directly from injuries sustained during the Civil War, but the Act of 1893 did not stipulate this. The new law also authorized the commission to purchase one hundred acres of land for the campus in an easily accessible location and to continue to operate other schools until all children could be transitioned to the new school. The commission's annual report for 1893 showed 439 children in the system, 194 at Chester Springs, 92 at Harford, 151 at Uniontown and 2 at other schools.

Early Years[7]

With state authorization, the commission used $12,000 to purchase from state senator Alexander Stewart one hundred acres of land in Scotland, Pennsylvania, a small village approximately forty-five miles southwest of Harrisburg.[8] The land, selected for its proximity to the central part of the state and its location on the Cumberland Valley Division of the Pennsylvania Railroad, had originally been part of a six-hundred-acre plantation called Corker Hill owned by Alexander Thompson, the first permanent settler in Scotland.[9] Its proximity to Chambersburg allowed easy access to basic resources. With mature maple trees and the Conococheague Creek running through the property, the location provided a lovely setting and allowed room to expand. After acquiring the land, the commission hired an architect and accepted bids to begin construction. Although the commission requested funding to build homelike cottages for student housing—an approach favored by an increasing number of child advocates at the time—the legislature initially only provided enough funding to construct a main building, a powerhouse and an industrial plant. Lack of funding and insufficient housing plagued Scotland in its early years and undermined the original goal of closing the other schools in the system.

Scotland School for Veterans' Children

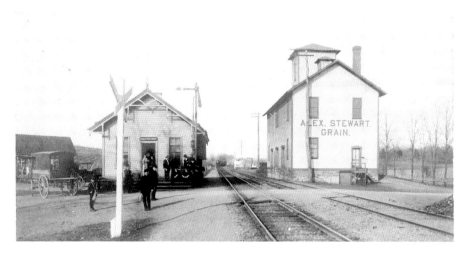

Cumberland Valley Railroad Station, c. 1890s.

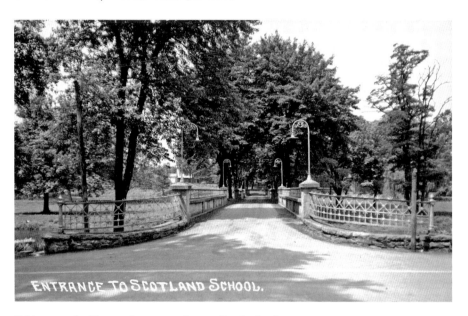

Bridge over the Conococheague to the tree-lined school entrance.

Because the new industrial school could not accommodate all the children from the three remaining schools, the 242 initial enrollees were mostly older children between the ages of twelve and fifteen who transferred to Scotland in order to receive industrial training before exiting the system. The Act of 1893 only officially allowed children to stay in the

system up to the age of sixteen, but in 1901, the legislature extended the law, allowing students who turned sixteen between January 1 and June 30 to remain at the school until June 30. Those completing their educations and exiting the system at age sixteen became known as "sixteeners." In 1905, an amended law allowed qualified students to stay in school until the age of eighteen. Although boys and girls of all races could attend Scotland, white students representing regions from around the state formed the vast majority during this early period.

Despite the best hopes of the commission, inconsistency in leadership, funding shortages, overcrowding and myriad other challenges hampered Scotland's first several years. Between 1895 and 1900, four different men served in the role of superintendent at Scotland. General Charles L. Young, the first of the four, joined thirty-three other employees, including four teachers, a principal, a nurse (his wife) and a local doctor, who came three days per week to provide health services.[10] Young endured a difficult first year and found himself on the receiving end of considerable criticism from Frank G. Magee, the commission-appointed school inspector, who bluntly reported on poor general management as well as unrest and insubordination among male students, frequent runaways, shabby clothing and defaced property.[11] In August 1896, the commission replaced Young with James M. Clark, but he fared little better, according to Magee. When the commissioners relieved Clark of his superintendent's duties in August 1897, they replaced him with none other than Magee himself. Magee, however, had only a short time to prove that he could do better than his predecessors because he died in April 1899, less than two years into his term, and was replaced by M.L. Thounhurst, Scotland's principal. In June 1900, Thounhurst, who had been part of the Civil War Orphan Program in various capacities for a long time and generally received high marks for competence, moved from Scotland to Chester Springs, leaving the industrial school without a superintendent once again.

In an effort to close the other schools in the system, these early leaders tried to stretch limited state dollars to pay for construction needed at Scotland. Burger and Son Construction Company completed the initial building, which housed all school operations other than the shops, and the industrial building prior to the school's opening, but many smaller building projects and capital improvements still needed to be completed after students arrived. By the close of 1897, a machine shop, forge shop and pumping station had been built, and renovations of the property's existing barn had begun. The school also put in a pond during the 1896–

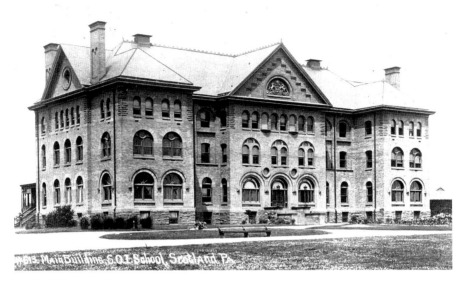

Main Building SOIS, built in 1895.

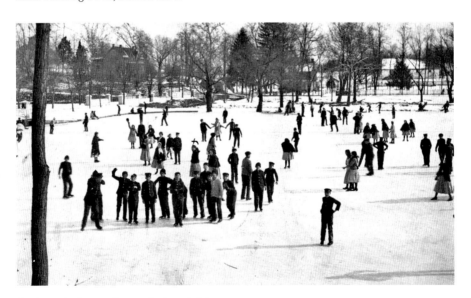

Students skating on the pond, circa 1900s.

97 school year, which spurred a long tradition of winter ice-skating and summer fishing. During the same year, Scotland added fire extinguishers and hoses and built a gun rack for firearms used by the boys in their military drills.[12]

Historical Overview

Putting in place the fire equipment proved to be fortuitous. On February 20, 1901, the school faced its first serious crisis, a fire in the engine room of the industrial building.[13] Thankfully, the fire apparatus worked well, and the system of hydrants and hoses saved the nearby boiler and laundry rooms. According to the head of Scotland's industrial department, school officials called the Chambersburg Fire Department to be sure windy conditions did not carry the fire to the main school building.[14] Unfortunately, the fire destroyed the electrical system and heating pipes, leaving the school without lights or heat for a short period of time. Some industries had to be temporarily relocated.[15]

During the same year, Scotland faced a major health scare with a scarlet fever epidemic affecting seventy-four students. Isolated in the farmhouse turned temporary hospital, all of them survived. The commission had called on the state to fund the building of a hospital in its initial plans, and school leaders had raised concerns about healthcare facilities in several of their early reports. In 1899, for example, the medical department noted the general inadequacy of the infirmaries and pointed to a discrepancy between the quality of the boys' and girls' facilities. Girls could only get to their infirmary by passing through the girls' dorm, thus exposing everyone to their illnesses.[16] The scarlet fever crisis increased the pressure to build a hospital at Scotland, and by the spring of 1901, the school had secured a contract of $7,650 to build such a facility.[17] The building remained in use until 1960, when it was razed and replaced in 1962 with a modern forty-eight-bed hospital.

After this initial period of struggle, the school gained stability under George W. Skinner, who served as superintendent from the summer of 1900 to 1909, and William H. Stewart, who left his position as the school's industrial education director to serve as superintendent from 1909 to 1920. This period saw the establishment of the school's basic infrastructure, curriculum, procedures and schedule. Daily living incorporated military drill and physical fitness for both boys and girls, academic and trades training for all students, moral training through Sunday school and chapel and regular work details. In the early days, Scotland established a strong music program, a fledgling athletic program for boys and a variety of extracurricular activities, including the school newspaper and a literary society. The daily schedule, containing few variations over the years, went as follows:

> 6:00 a.m.: Wake up, calisthenics for ten minutes, wash and dress for breakfast

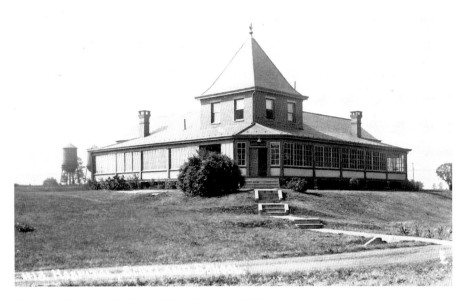
First school hospital, built in 1901 and razed in 1960.

> 6:30 a.m.: Breakfast followed by work detail
> 8:00 a.m.–8:30 a.m.: Drill or band
> 8:45 a.m.–11:45 a.m.: School and trades
> 12:00 p.m.: Lunch followed by free time
> 1:00 p.m.–4:00 p.m.: School and trades
> 4:00 p.m.–5:30 p.m.: Sports and other extracurricular activities
> 5:30 p.m.: Dinner followed by free time
> 7:00 p.m.–8:30 p.m.: Study hour for older children
> 9:00 p.m.: Taps and Bed

School leaders believed this strict daily routine gave students stability and discipline.

While Superintendent Skinner established routines at Scotland, he continued to deal with overcrowding and a state legislature unwilling to invest in school expansion. The closing of Harford—the smallest of the three remaining schools—in 1899 and the transfer of students to Scotland without any new construction led to worse overcrowding. By June 1906, Scotland housed 333 students in facilities originally designed for no more than 300, prompting the Pennsylvania legislature on June 13, 1907, to approve funds to enlarge the capacity of the school. Construction began on an auditorium/

Historical Overview

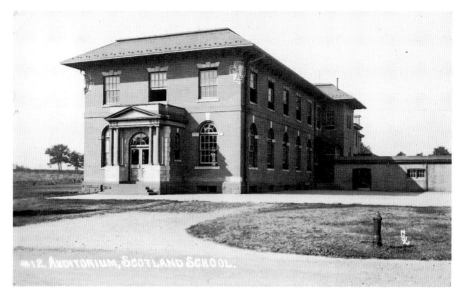

Auditorium built in 1907 and girls' dormitory, added in 1912.

chapel, including a second-floor dormitory, near the main building. This space allowed some of the younger boys to move out of the main structure, an especially important step at the time because Uniontown closed on May 31, 1908, and approximately 100 additional students transferred to Scotland. Builders added a new kitchen to the main building that year, as well.

With the May 31, 1912 closing of Chester Springs, the last of the schools in the original orphan education program, approximately 200 children, many very young, transferred to Scotland. This increase in the student population to almost 550 people resulted in the construction of a girls' dormitory at the rear of the new auditorium. Eventually, an above-ground enclosure connected the girls' dorm and the auditorium to the main building. This structure, referred to as "the tunnel," allowed students and staff to move freely between the buildings without having to go outside and remained in place until 1951, when it was torn down as part of a renovation project on the main building.

When the new academic year began in the fall of 1912, with all of the children at Scotland, the school reached capacity, but officials hoped they would be able to admit more children as students left due to age. This also marked the first time the industrial school took on the care of young children, requiring changes in discipline and curriculum as well as staffing.

Several members of the Chester Springs staff moved to Scotland, and school officials organized the young boys into a division known as the "little line" to distinguish them from the "large line" of older boys. In many respects, the fall of 1912 marked a promising time for the school because at least one of the commission's major goals—consolidating the system at one facility—had finally been achieved.

In the decade following the final consolidation of the schools, enrollment at Scotland began to decline from 550 students in 1912 to a low of 178 in 1924 before gradually beginning to rise again.[18] School leaders expected World War I to increase applications for admission, but for unclear reasons, this did not happen in the immediate aftermath of the conflict. The war, nonetheless, affected the school in a number of ways. In April 1917, the school erected an impressive new one-hundred-foot-high steel flagpole that became an iconic image of patriotism.[19] The focus on military drills sharpened as Scotland joined in preparedness movements emerging around the country. Some staff members and students left campus to enter military service, a point of pride noted in both annual reports and the school newspaper. In December 1917, for example, the school newspaper listed former and current members of the Scotland School community serving in the war effort, noting that one alumnus was serving as navy band master while two others played in the army band. The 1918 Annual Report noted 152 names of graduates from Scotland and other orphan schools in the program, including one woman, who had been inscribed on a Roll of Honor for their service in the war and pointed out more may have served.[20] Rising prices as a result of the war strained the school's budget and caused a significant deficit by June 1919. A series of epidemics between 1913 and 1919 added to the budget problem, as the school had to provide more medical care and hire additional nurses. The 1917–18 academic year proved most difficult, as smallpox, scarlet fever, measles, diphtheria, chickenpox and pneumonia all "swept through the school," resulting in two deaths.[21]

When William Stewart resigned as superintendent in 1920, the commission appointed then principal/assistant superintendent William C. Bambrick to replace him. Despite his twenty-five-year association with the school in various capacities, Bambrick only lasted one year as superintendent before being removed by the commission on a 4–2 vote in 1921. The commission replaced him with George C. Signor, who served until 1924. Although he did not have a background in education, Signor's experience in agriculture and public works led him to focus much of his attention on Scotland's infrastructure and on expanding the school farm. Signor's initial report to the commission

Historical Overview

on June 21, 1921, outlined a number of repairs and improvements needed at the school and offered a substantial list of recommendations, including updates to the school's plumbing and electrical systems, which he said would be needed in order for the school to pass public health inspections. By way of example, he reported only three working bathtubs for all of the girls at the school. Signor also recommended new flooring, an updated refrigeration and ice system and a dishwashing machine. On a humanistic note, he stated in his report that girls of a "tender age" spent too much time washing dishes and had no free time.[22]

Throughout his tenure, Signor, fearing the school risked failing public health and safety inspections in a number of areas, lobbied the state to invest in the school even if it meant a temporary deficit. When he hired a company to test the school's water, inspectors found it contaminated, and Signor speculated this was a contributing factor in numerous reports of stomach problems at the school. In response to the finding, Signor proposed a deal with the neighboring farmer, a Mr. Burgner, to use his spring as a water source in return for providing the neighbor water and electricity for his house and barn. In addition to rectifying public health concerns, Signor argued that investing in improvements to the industrial program and farm would make the school more self-sufficient and save the state money in the long run.

In addition to expanding the slaughtering operation, increasing the amount of canning and preserving of vegetables from an extensive garden and building a root cellar, Signor convinced the commission to lease with the option to buy an additional eighty acres of land from an adjoining farm in order to increase production of wheat, oats and hay. In his report for the October 10, 1923 meeting of Scotland's newly formed board of trustees, Signor noted the school had been brought up to code as a result of electrical and plumbing improvements and added safety features to a number of machines.[23] He also summarized with notable pride increases in farm production and work being done by the tailoring, shoe repair, laundry, dressmaking and mechanical departments on behalf of the school. He even credited a Miss Morehead in the laundry for coming up with the "ingenious idea" of using the dryers as evaporators to "finish" vast amounts of sweet corn (eight hundred pounds that year) being produced by the school.

At this same meeting for which Signor had prepared his positive report, the board passed a resolution to investigate the management of the school. The minutes do not reflect why they took this step, but board members may have been concerned that Signor's focus on the school's physical plant and

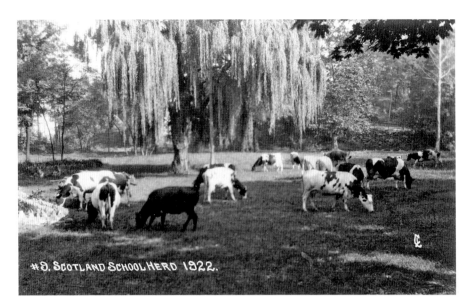

School herd, circa 1922.

farm detracted from other aspects of management. In the end, it proved not to matter because at the February 14, 1924 board meeting, Signor offered his resignation effective April 1, 1924, citing health reasons. At the very same meeting, the board voted to approve Colonel C. Blaine Smathers as superintendent, suggesting that members had likely been considering such a change for some time. Smathers, who combined a military background with many years of experience in education both as a public school superintendent in the Grove City Schools and as a member of the Pennsylvania Department of Public Instruction (later Department of Education), led Scotland for the next sixteen years and was eventually promoted to major general.

Expansion and Academic Advancement

Among other goals, Smathers (1924–40) sought to raise the school's academic standards. In 1924, when he recommended the board hire John G. Allen as school principal—a position Allen held until 1941 when he assumed the superintendent's position himself—Smathers made it clear that he wanted Allen to overhaul the school's curriculum and teaching practices. The decision that same year to rename the school the Pennsylvania Soldiers'

Historical Overview

Orphans School (SOS), dropping the word "industrial" from the title, further represented a desire on the part of school leaders to advance and legitimize the school's academic program even as it maintained coursework in a variety of trades. Allen sought guidance on improvement plans from the Pennsylvania Department of Public Instruction, and his efforts bore fruit on January 8, 1928, when Scotland gained official state accreditation. Under Smathers and Allen, Scotland prioritized curriculum revision, new programs and professional development for teachers (see chapter 4).

At the same time Smathers focused on curriculum matters, he attended to the school's physical plant. With recognition that no new buildings had been constructed on the campus since 1907, Smathers began almost immediately by gaining approval in 1925 for a new $75,000 gymnasium to supplement a modern playground, tennis courts, a baseball field, a track and a football field. In 1927, as enrollment finally began to rise again, the school added a one-story buff brick boys' dormitory attached to the administration building and connected to the dining hall. In addition to sleeping quarters that allowed the boys to leave the dark basement of the administration building, the new building contained an office, a locker room, an assembly hall, a lounge and reading room, a barbershop, a lavatory and shower room and a clothing room.[24] On October 5, 1929, the board approved the construction of an on-campus superintendent's house, which still stands today. A school building, enhancing the learning environment for students and freeing up space for housing in the administration building, went up in 1932–33 at a cost of approximately $105,000. A new trades building came in 1939. Perhaps most importantly, under Smathers, the board finally secured funding from the state to build the initial cottages that had been such an integral part of the commission's original vision for the school. Over the next several decades, the school built forty-one cottages.

When J.G. Allen took over the superintendency in 1941, he continued Smathers's policies. With the advent of U.S. involvement in World War II, however, he also turned his attention to the war effort. Scotland introduced a new, even more intense, military drill program in order to prepare students who might enter the war after graduation. On December 23, 1942, following the precedent from World War I, the state approved a wartime acceleration policy allowing students to leave for the service during their last year of high school and still be given their diplomas. Ultimately, 318 identified Scotland alumni served in World War II, and 14 perished in action or from wounds.[25] In addition to expanding military drill and placing additional emphasis on citizenship and patriotism, the school supported the war effort in a variety of ways.

Original gymnasium, built in 1925.

School building completed in 1933.

To cut back on spending, the administration put capital improvements on hold and eliminated some extracurricular activities, including football games requiring travel of more than fifty miles. School leaders rationed food, as

Historical Overview

Original trades building, built in 1939.

required by the federal government. Allowed only two food purchases per year during the war, Scotland had to stockpile canned goods with the hope of not running out before the next purchasing date. Students joined the Junior Red Cross, collected and sold tin cans and helped local orchards by picking apples that would have perished due to war-induced labor shortages. The school-appointed "scrap warden" reported collecting eighteen thousand pounds of scrap metal in 1942. In addition, Allen submitted to the government a list of all the school's training facilities in the event they could be of use. The American Legion, which had long supported an annual trip to Washington, D.C., for graduating seniors, shifted course in 1942 and provided each graduate with a twenty-five-dollar war bond instead. In one of the school's more interesting efforts, students began an extensive program of building model planes for the U.S. Navy. Remarkably, Scotland's quota for model plane production in 1943 was set at 300,000 for the year. Volunteer students built 80 different plane types, both Axis and Allied, and sent them to the Middletown Air Depot. From there, they were distributed to air raid wardens, plane spotters and aviation cadets around the country to help them identify aircraft.

In addition to experiencing the effect of World War II, Scotland students in the 1940s first enjoyed what became a longstanding tradition at the

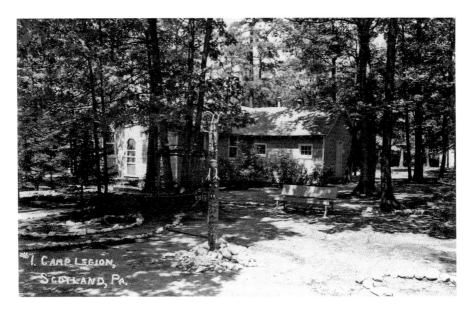

Building at Camp Legion, opened in 1942.

school: summer camp at Camp Legion. In April 1941, Allen asked the board to look into purchasing a nearby Civilian Conservation Corps (CCC) camp to be used in the summer by students who stayed at the school. The following spring, Allen reported that the American Legion had purchased the buildings at the Still House Hollow CCC Camp, located in a woodsy area on South Mountain approximately seven miles from the school. The group then turned the facility over to the school for the proposed summer camp. That first summer (1942), sixty-two boys and sixty-five girls spent three weeks at the camp. Over the next several decades, hundreds of Scotland students enjoyed Camp Legion. The time spent at the camp varied from as many as five weeks to as few as two weeks, with three or four being the most typical.

In May 1945, just as the war in Europe ended, Pennsylvania passed Act 72A, which appropriated $7 million for postwar construction in state educational facilities. Anticipating enrollment increases after World War II, the state allocated to Scotland almost $1 million of those funds for postwar renovations and construction. In addition to that money, construction funds came from the General State Authority. As a result, in the late 1940s and early 1950s, Scotland began a number of infrastructure projects. While the postwar enrollment estimate of 1,200 students never came to pass, the numbers did increase considerably, peaking in 1965 with 566 students. At

the same time, fewer students in the postwar period arrived at SSVC as orphans. More often, they came from homes in which parents could not meet their needs due to a range of issues, including disabilities, poverty, postwar psychological conditions and substance abuse. In order to more accurately reflect the changing student body, the board of trustees approved a second school name change in 1951. The Pennsylvania Soldiers' Orphans School (SOS) became the Scotland School for Veterans' Children (SSVC), the name it kept for the rest of its history.

In the fall of 1951, Superintendent Allen, suffering from congestive heart failure, took a leave of absence and turned over day-to-day operations of the school to assistant superintendent Maurice "Cap" Heckler, a former student and longtime employee of the school. Heckler faced an immediate challenge on November 20, 1951, when a devastating fire destroyed the school building. The fire, believed to have been caused by defective wiring, was discovered at approximately 8:50 p.m., only twenty minutes after students left study hour in the building. Despite efforts from several local fire companies, the fire burned for nearly five hours. Due to extensive damage, the school building, including two new wings, did not reopen until 1954. Six decades later, former students and staff vividly recall that night. Science teacher Ray McKenzie, only in his second year at Scotland at the time, described playing cards with some fellow teachers at a house across the road and looking out the window to see the building going up in flames. He also recalled how for three years, teachers and students had to get by with makeshift classrooms in various locations across campus, including in converted living spaces within some of the cottages.[26]

As Maurice Heckler dealt with the aftermath of the fire, J.G. Allen's health continued to fail, and he died on January 5, 1952. Together with his predecessor, Blaine Smathers, Allen had solidified the school's military tradition and expanded and strengthened its academic program. He shepherded Scotland through the challenging days of World War II and led the early years of the postwar expansion. His death had a significant effect on the school, and his open casket was placed in the living room of the superintendent's house so that students and staff could view his body and pay their respects, an experience that left quite an impression on a young girl named Anne Elder '56, who described the experience more than sixty years later.[27]

When hiring Allen's successor, the SSVC Board of Trustees established a new set of guidelines with greater emphasis on candidates' experience in education. They wanted an individual who would understand children's

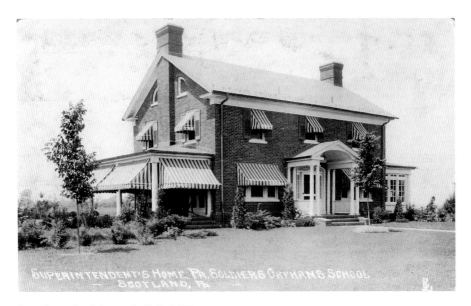

Superintendent's house, built in 1930.

developmental and learning needs as much as their need for discipline and structure. The board recommended Dr. Willard M. Stevens, a commissioned officer in the navy during World War II with education degrees from Penn State and the University of Pittsburgh. He came to SSVC with twenty years of experience in education and served as superintendent from 1952 until 1966.[28] Stevens kept Maurice Heckler—a man well known for both his strict discipline and love for Scotland and its students—on as assistant superintendent.

With the influx of postwar funding from the state and Stevens's fundraising skills, Scotland's physical plant changed considerably during his tenure. In his first years, he oversaw the completion of several projects begun before his arrival. The new fireproof school building, for example, did not reopen until the fall of 1954. A major remodeling of the main administration building—deemed unsafe and scheduled for refurbishing in 1946—concluded in 1953. As part of the remodeling, smaller bath and apartment units designed for eighteen boys on the second and third floors replaced dormitories for the boys' large line. Younger boys and the girls lived in cottages by this point.[29] In addition to these projects, the school received a new laundry building, a power plant, a hospital, a natatorium and several new cottages all during Stevens's term. During his final year as superintendent, the school added a garage and auto shop to its facilities. A

HISTORICAL OVERVIEW

Natatorium, circa 1950s.

true advocate of SSVC, Stevens continued to actively support the school in retirement as Scotland School chairman for the Pennsylvania American Legion. In this position, he lobbied the group to establish a scholarship fund for Scotland students.[30]

CHANGES AT SCOTLAND

During the period between 1966, when Stevens retired, and 1991, when Frank Frame served as superintendent and led Scotland through the first serious attempt by the Pennsylvania legislature to close the school, four different men served the superintendency. Each one brought both military service and educational experience to the position. When Stevens resigned, Dale H. Reinecker, assistant superintendent of the Carlisle Area Schools and active member of the air force reserves, became superintendent and served until 1973. He was followed by two World War II veterans, James R. Heckler (1973–78) and John E. Jannuzi (1978–84), both of whom knew the school well before assuming their roles as superintendents. As the son of SSVC alumnus and longtime employee Maurice "Cap" Heckler and Marjorie Maclay Heckler, a former elementary teacher at Scotland, James Heckler

brought to the position a deep understanding of the school's tradition. In addition, he offered experience in educational leadership, having served as superintendent of Cumberland Valley School District before coming to Scotland. John Januzzi arrived at Scotland as a social studies teacher in 1952 and worked his way up the ranks as principal and assistant superintendent before taking up the superintendent position. Upon Januzzi's retirement, Lieutenant Colonel Francis J. Calverase (1984–90), a West Point graduate, became superintendent. Calverase first arrived at Scotland in 1980, having retired from the military after twenty-one years of service, as an instructor for the newly developed Junior Reserve Officer Training Corps (JROTC).

Under each of these men, Scotland's mission to serve veterans' children remained relatively constant, but the school began to change in other ways. The demographics of its student body shifted from a predominantly white population, with clusters of students coming from different regions around the state, to a predominantly black population with students coming mostly from Philadelphia (see chapter 2). Few students during this period were orphans, and most maintained stronger ties with parents and family than had students in previous generations. They often went home for vacations and in the summer.

One former teacher whose Scotland career began in the early 1950s and ended in the 1980s described this change by saying that prior to the 1970s, SSVC was a "true home" to most students; after that period, it was more of a traditional residential school with a much higher level of parental involvement. Under Superintendents Januzzi and Calverase, the school instituted annual Parents' Days and eventually supported the establishment of the Scotland School Parents' Association. Virginia James, a grandmother of one of the students from Philadelphia, initiated and originally led this group. During his tenure, Frank Frame fondly recalls a close working relationship with James, who continued to promote active parental involvement at Scotland. Over time, new admissions policies extended enrollment to veterans' stepchildren and eventually to grandchildren, nieces and nephews, as the school sought to maintain a healthy enrollment. Despite heavy American casualties during the long Vietnam War, however, enrollment at SSVC never again reached its 1965 peak.

During this period, the school also saw changes in its academic and military programs, as well as continued improvement to its facilities. Superintendent Reinecker oversaw several upgrades to the school's physical plant, including the addition of a library and science wing to the school building in 1972 as well as the construction of a new chapel in 1970 and a new gymnasium

in 1972. During Reinecker's tenure, the school also capitalized on Title I funding from the federal government to develop several new programs. Title I, established under the Elementary and Secondary Education Act (ESEA) of 1965, sought to close the student achievement gap by providing funds for remediation and other special initiatives to schools with a high proportion of low-income students. Scotland used the money to establish a summer school program, a formal guidance department, reading and mathematics labs and an outdoor education initiative (see chapter 4). This period also brought the school's first computer lab. In addition, with the introduction of JROTC at SSVC in 1980, the school's military program moved in a new direction with an enhanced focus on leadership training for boys and girls alike (see chapter 3).

By late 1990, when Superintendent Calverase resigned his position and Frank Frame replaced him (first as acting superintendent), the Scotland School found itself in a somewhat vulnerable position. Despite the leadership's best efforts, enrollment dropped, per-pupil costs rose, infrastructure aged, the trades curriculum lost relevancy and the governor sought means to save money in the state budget. In many ways, SSVC's ensuing struggle to remain open when the state called for its closure in 1991 shaped events for the rest of its history. The details of this period are taken up in the final chapter of this book, but it should be noted that during the same period, Scotland benefitted from an enormous boost in pride and recognition as it entered a golden age of athletics. For most members of the public who either did not follow the press coverage concerning the 1991 struggle or who considered the matter settled once it became clear Scotland would stay open, it was the school's athletic accomplishments that most characterized the 1990s and early 2000s. In the spring of 1991, as SSVC's fate hung in the balance, the boys' track team provided a much-needed morale boost by winning the school its first-ever state championship. Over the next twelve years, building on a century of athletic tradition, Scotland teams amassed a staggering ten more state championships (in three different sports) and sent numerous students to college on athletic scholarships (see chapter 5). Despite these successes and the efforts of school administrators to strengthen programs and manage costs, when the great recession of 2008 hit Pennsylvania, the Scotland School found itself once again in the crosshairs of state budget disputes. In 2009, the struggle ultimately proved fatal to the school.

2

Scotland "Kids"

On October 30, 1944, eight-year-old Jerry Sanner sat down to write a letter to his mother. In nearly perfect cursive handwriting, he assured her that he was well, told her he had been placed in the third grade and asked that she send him a picture of herself as a reminder of home. Jerry said nothing in his letter of missing his mother or of the fear and bewilderment that came from living among strangers at such a young age. It is a brave little letter, poignant in its simple and earnest message. As he navigated a world that surely must have seemed overwhelming and strange at the time, Jerry could not have known then that he would eventually come to love Scotland and thrive academically and socially in its highly structured environment. Nor could he have imagined that some seventy years later he would fly across the country for a Scotland reunion carrying a beautifully preserved Scotland scrapbook containing everything from dance programs and soccer pictures to the letter his mother had kept.[31]

Jerry is just one of thousands of children who spent their childhoods on the Scotland campus and came of age in its particular culture of care and discipline.[32] Like it or not—and there were plenty of students in both categories—Scotland School became home to these children, the place where they shared their most formative experiences and learned to make sense of the world. Like most young people, they studied and played and did chores; they tasted success and faced disappointments. Many made great friends; some fell in love. Others struggled to fit in or faced bullying and felt uncertain about what life would bring. None wanted to be pitied; all wanted to be valued. In these ways, they were like any

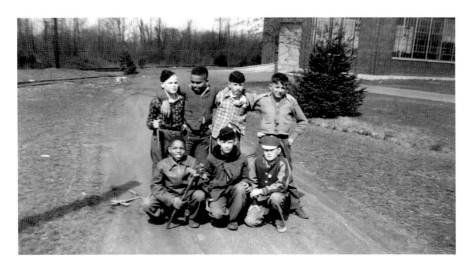

A group of friends, circa 1951.

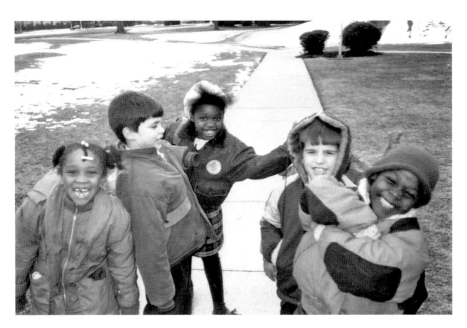

Children playing together, circa 1980s.

other kids, yet children and adolescents at Scotland lived a very different kind of life than most people their age. Not residing in homes or within family units, they had to figure out how to make their way in a highly structured institutional environment that could be simultaneously loving and harsh.

After going through the initial adjustment period, Scotland students who remained at the school for a number of years generally came to view their Scotland days in one of three ways.[33] Some thrived at the school relatively quickly and came to view it with affection, loyalty and pride. They enjoyed their days at Scotland and, in many cases, believed that Scotland "saved their lives." Other students resisted or even "hated" their day-to-day experiences at the school but after graduating came to appreciate what the school had given them. A third group continued to view the school with mixed feelings or with outright hostility long after they had left. Whatever their viewpoint, many former Scotland students clearly found a home and a family at the school—in some cases the only one they had. Admissions guidelines changed over the years, as did the social, political and family issues confronting them, but to thousands of vulnerable, veteran-affiliated children in the commonwealth of Pennsylvania, the school remained a refuge for more than a century. These "kids"—as many alumni still like to call themselves—are at the heart of the Scotland story.

Who Were Scotland Students?

Scotland students shared much in common, but it would be impossible to describe a typical Scotland experience. For one thing, students entered the school at different ages and stayed for varying lengths of time. In addition, children experienced more or less family involvement in their educations, often depending on the time period in which they attended. Students' life experiences prior to admission ranged from moderately challenging to extraordinarily difficult, with some coming from relatively stable family environments and others coming out of foster care or child protective services. As with all schools, Scotland students represented various levels of academic ability, talent and motivation and arrived with different interests and needs.

In addition to these specific characteristics among individual students, the makeup of the student population as a whole, especially in racial composition, parental status and home area, evolved over time. The industrial school that opened in 1895 did not discriminate based on race, but it served mostly white students who came from counties across the state. Frequently, incoming students had no living parents when they entered the school. When the school closed in 2009, its student body comprised mostly

Boys in their cottage, circa 1954.

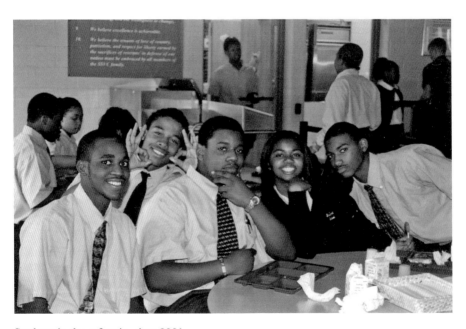

Students in the cafeteria, circa 2001.

African American students with one or both parents still living, coming largely from Philadelphia. Several factors contributed to this evolution, which accelerated in the 1970s. As more African American children became eligible to attend Scotland, due in large part to the increasing number of black soldiers serving during the Vietnam era, it did not take long for word of the school to spread in some African American communities and for parents to see it as a viable option for their children. The increase in black military veterans also coincided with a particularly troubled time in Philadelphia's history, when neighborhoods saw increases in poverty, crime and violence. For many families, Scotland emerged as a haven for their children, and enrollment there alleviated some of the stressors they confronted. For the admissions staff at Scotland, Philadelphia became a primary recruiting area.

At the same time that African American attendance increased, the overall percentage of veterans leaving behind full orphans decreased as a result of longer life expectancies and better healthcare for both veterans and their spouses. The reduced number of orphans, combined with an increase in veterans' benefits and social services provided through President Lyndon B. Johnson's Great Society initiatives in the 1960s, meant fewer white parents turned to Scotland as an option for their children. For the SSVC admissions staff, bringing in students from rural areas, especially in the western part of the state, became more difficult. On a recruiting trip to the Pittsburgh area in 1983, admissions director Jerry Stewart described to a reporter for the *Pittsburgh Press* how he found a "personality difference" between the eastern and western parts of the state. He said, "Western Pennsylvania seems to be more tightly knit, and in a crisis there's a tendency for children to be passed from one family member to another rather than to an outside agency."[34] It is difficult to confirm the accuracy of Stewart's assessment, but it is certainly true that the Scotland population became more concentrated with students from the eastern part of the state.

In addition to these shifts, the state's view on enrollment eligibility continued to transform throughout the twentieth century, as the United States participated in more wars and various stakeholders called for the expansion of admissions criteria. When it opened, the school only admitted children whose biological fathers had been combat veterans of the Civil War, had lived in Pennsylvania for five years and had died or become too disabled as a result of the war to care for their children. Over time, the guidelines changed to allow admission for both natural and adopted children of male *or* female combat veterans of various wars and conflicts. Eventually, the school reduced the Pennsylvania residency requirement

from five years to three and admitted children whose military parents had not served during combat. In an effort to boost enrollment in its final years, the school opened its doors to stepchildren, grandchildren and nieces and nephews of Pennsylvania veterans.[35]

Despite these changes and the debates that revolved around them, one can find many similarities between Scotland's first students and those who followed them for the next 114 years. First, all Scotland students, from 1895 to 2009, connected in some way to a Pennsylvania veteran. In fact, the school's long-standing position—that children of military veterans were in a special category—predated its founding. In 1864, when Governor Curtin established the Civil War orphan care program in Pennsylvania, he did so believing that no veteran killed serving his country should leave behind a homeless child. While recognizing the presence of other vulnerable youths in Pennsylvania, Curtin viewed veterans' children as especially deserving of protection. The Pennsylvania Soldiers' Orphans Industrial School reflected this protective mission when it opened in 1895, and the Scotland School for Veterans' Children continued to embody it until the day it closed. Many of the most vocal advocates for keeping the school open, both in 1991 when the state first tried to close it and again in 2009 when it finally did, argued on grounds similar to those espoused by Curtin almost 150 years earlier.

In addition to the military connection, Scotland students almost always shared challenging circumstances, either within their own families or within their home communities, prior to coming to the school. Some had endured abuse or neglect, and many came from extreme poverty. In some cases, protective services took children into custody and sent them to the school as an alternative to foster care. Other times, parents or guardians who felt ill-equipped to provide the best care for their children and/or who wanted them to grow up in a safe place made the arrangements. No students came to the school due to court order resulting from any form of delinquency. Despite occasional misperceptions on the part of some members of the public, Scotland never served as a school for juveniles with criminal records. Nor did it ever serve children with severe diagnosed academic or physical special needs or with drug or alcohol dependency. As a general rule, students took both academic and psychological tests prior to enrollment, and school officials made it clear that Scotland served students who could perform in a general education environment.

The extent to which eligible children knew of or participated in the decision to send them to Scotland varied considerably. Many, especially prior to the early 1970s, arrived at the school not fully understanding where

Scotland "Kids"

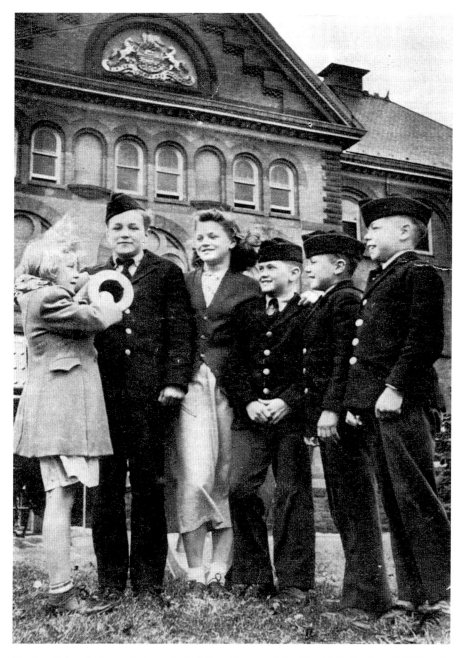

Trexler siblings in front of the main building. *Courtesy of Ann Harold Trexler, class of 1955, and Donald Trexler, class of 1955.*

they were or if their families would be coming back for them. Some had regular visits from family members and went home in the summer, while many others rarely saw their parents or guardians and lived at the school year-round or spent summers with foster families. Many children came to Scotland with their siblings, but others were separated from brothers and sisters who went to other schools or who were too young or too old to come to Scotland. Some students, especially in the later years, came with their own clothing, special belongings and family pictures, while others came with little more than the clothes they wore.

Whatever their individual circumstances, Scotland students had generally endured varying degrees of difficulty by the time they arrived, often frightened and troubled, at school. They came to a place meant to provide a safe and secure home as well as an education. The extent to which Scotland fulfilled that mission varies for individuals, but beginning with the commissioners who proposed the cottage system in 1893, school leaders always stated their clear intent to create a "homelike environment." Many former students suggest that the school achieved this goal. They describe finding not only structure and stability at the school but also meaningful relationships with caring adults and especially with their fellow students. Others found the regimen and discipline stifling and the corporal punishment excessive. Adjusting to life at Scotland was almost always difficult, but some students, especially those enjoying three meals a day and a bed of their own for the first time, settled in more quickly than others.

Where Did Students Come From?

Whatever their particular circumstances, children came to Scotland when someone with authority over them decided they would be better off living at the school than in their present situations. In most cases, both the school and the person(s) sending the children expected them to stay at Scotland until they had finished their schooling and reached adulthood. It did not always work out this way, but the school aimed to provide long-term care and education rather than a temporary residence for students hoping their home circumstances would improve.

A child already under the care of protective services typically ended up at Scotland if case workers knew about the school and knew that the child had a qualifying veteran connection. One graduate, George '45, for example,

explained that he had been in and out of orphanages and foster homes from the age of two before being sent to Scotland at age six.[36] Andy '44, who arrived at the school at the age of eight or nine under similar circumstances, recalled, "My mother died at thirty-four years of age and my father died when he was thirty-six from World War I. He was gassed twice in Germany, and there was eight of us. There was two sisters and they came here to Scotland and two brothers. Two brothers went to Milton Hershey. My oldest brother, he was in the United States Army at that time."[37]

Some children who had been placed initially in other orphanages came to Scotland as a result of intervention by relatives who knew of the school. George '63 ended up in the Milton Wright Home for Orphans after becoming a ward of the state due to his father's difficulty with what today would be call post-traumatic stress disorder stemming from the Korean War and his mother's inability to care for him and his siblings. He and one of his brothers moved from Milton Wright to Scotland.[38]

Often adults did not tell children about the decision to send them to Scotland until they actually arrived at the school. The experience of Granville, who spent close to ten years at Scotland and graduated in 1941, shows the kind of confusion children often felt when they were dropped off at the school without warning. Granville's father came out of World War I "shell shocked" after having been exposed to mustard gas. At some point early in Granville's childhood, his father simply "disappeared," leaving his mother to support the children by washing clothes for pay. Eventually, the family moved to Granville's grandfather's farm. As a nine-year-old boy, Granville adored both his grandfather and the farm, but he was too young to see how much his mother was suffering. One day, his grandparents told him and his two siblings they were "going for a ride in the car." They arrived at Scotland School, completed paperwork and took a tour, but the children did not understand why they were there. Decades later, Granville recalled his initial reaction.

> *I was at that time, nine or ten years old. I'm just not quite sure. So we went around the school; they showed me this and showed me that. I wasn't too impressed about it. So it got late in the afternoon. My grandfather had a farm. I was his namesake, and he was my idol. So I said to the lady there, "Excuse me, I've got to get back to my granddad's farm." She said, "Well, you're not going back," and then she handed me some clothes. I said, "What's this?" She said, "This is your clothes you're going to wear at the school." I looked perplexed and said, "What, do you mean I'm going to*

stay here at the school? I've got to go back and help my grandfather. Where's my brother and sister?"[39]

What Granville did not know at the time was that after that day, he would not see his grandparents again or hear from his mother for many years.

Even if they cannot remember details of their first days at the school, many former Scotland students recall an initial feeling of abandonment when they arrived. Tedd '60 put it most succinctly when he recalled how his mother and grandfather dropped him off at Scotland on his ninth birthday. He said, "I don't remember much about that day except [they're] *gone*, and I'm still here."[40] His father, a World War I veteran, had died in 1949, and his mother could not afford to care for him and his brother. Like Tedd, many students arrived at Scotland primarily due to their parents' strained financial circumstances and, in some cases, extreme poverty. Shirley '56 came to Scotland just shy of her fourteenth birthday. She had two living parents, but her father, a navy veteran, lived away from the family. From her earliest memories until the day she arrived at Scotland, Shirley lived in terrible poverty. In addition to surviving a severe case of rickets and being so cold in an unheated house that she felt like she was "freezing to death," Shirley remembered almost always being hungry. She described how her mother managed to feed the family.

> *When I say we were poor, a lot of times we ate brown flour gravy three times a day. Poor man's pot pie was a tablespoon of homemade lard in a kettle of boiling water and potatoes and dough. We had a butcher shop at the top of the hill, and back then dried beef was cheap. We would buy a quarter of a pound for six [people]. We would really stretch it out as far as we possibly could. But every time I went to the butcher shop, it was a cardinal sin if I didn't ask for a dog bone. Now the dog eventually did get the petrified bone after we cooked it to death and it was really white. He did get the dog bone, but we got all the goodies and flavoring that could possibly be there.*[41]

Shirley adjusted well to her life at Scotland and credited the school's academic and extracurricular programs with much of her adult success, but she never failed to appreciate the basic comfort of receiving regular meals at the school.

Some students, especially those graduating prior to the 1970s, recalled coming to school having never had indoor plumbing or a regular bed on

Scotland "Kids"

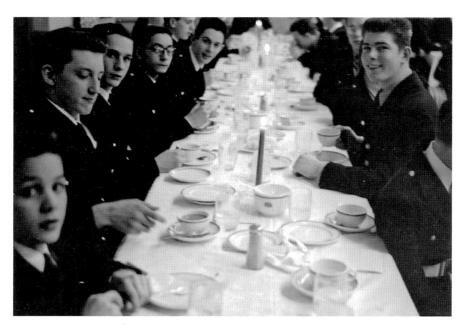

Boys at a banquet dinner, circa 1956.

which to sleep. Even more recent graduates who generally lived in homes with plumbing and electricity sometimes had to go without basic services due to unpaid bills. Lisa, who attended Scotland for several years in the 1980s, made this point while noting how grateful she was for her father's military service. She described her parents' divorce and the financial challenges that ensued in her single-parent home.[42] For many students in similar circumstances, being able to live at Scotland while their parents dealt with the uncertainty of evictions or the struggle to stretch groceries provided some degree of day-to-day relief and security.

Because families and social workers did not always know of Scotland's existence, the school and the veterans' organizations supporting it publicized as widely as possible throughout the state. As previously noted, for much of the twentieth century, students came to Scotland from all over Pennsylvania, and the student body represented a cross-section of families from rural, urban and small-town communities. By the 1970s, however, when both the composition of the student body and the reasons for enrollment began to shift, parent requests to enroll their children at Scotland became less about individual family crises and more about a desire to remove their children from what they considered to be unsafe environments and ineffective public schools in urban areas. Mike '91, who spent twelve years at the school,

reflected on what his life might have been like had he stayed in his home community of Philadelphia and explained the appeal of the school to parents in the city.

> *I think, me personally, it's easier to recruit a kid from Philadelphia. Can you imagine going into a parent's house and telling them that you don't have to worry about guns being at school or not being able to walk home and people picking on you. You would love the environment for a black kid, and this school....I mean, me personally, if I didn't have this school, I don't know if I was going to be a street kid or selling drugs or anything. Because I could just look at my neighborhood and the kids who I grew up with, that's what many turned out to be.*[43]

Although specific conditions in Philadelphia changed from the 1970s to the 2000s, many other staff and alumni echoed Mike's explanation of Scotland's appeal to families in that area.

Whether due to poverty and isolation in rural Pennsylvania, family dysfunction brought on by hardship, complex challenges of urban neighborhoods or, in some cases, wartime trauma, Scotland students knew what it meant to struggle. It was not uncommon, especially before the 1970s, for students to arrive at the school at the age of six and to leave at the age of seventeen or eighteen with minimal contact with their families. Some students healed and thrived while others never got over their resentment of the place and all the pain and loss that it may have come to represent for them. Whatever initial misgivings or relief children felt upon finding themselves at Scotland, many would live at the school for the duration of their childhoods. With few choices, they adjusted to the reality of this new home and began building relationships to comfort and sustain them in the years ahead.

Finding a Home and Family

When children arrived at Scotland, they faced immediate challenges. In addition to adjusting to the discipline and day-to-day structure, many also struggled with feelings of homesickness or abandonment and painful memories. Even those students who played an active role in their admission to Scotland and felt happy to be there needed time to

Scotland "Kids"

Cottage area.

make sense of their surroundings. By the 1930s, most students moved into cottages designed to house twelve to fourteen children and a house mother, known then as a matron. Older boys may have moved straight into the boys' dormitory in the main building as part of the large line. Either way, they had to adjust to living with complete strangers who would, in effect, take on the role of siblings.

It would be difficult to overstate the trepidation felt by most newly arrived Scotland students as they moved into their rooms and met the people with whom they would be living. Bill and Connie, biological siblings who graduated in the 1950s and ultimately came to love the school, described their initial fear. Bill recalled, "I remember they took me to one of the cottages and I had to put this uniform on. I simply ran out of the cottage and ran, ran, ran, as far as I could, and then somebody grabbed me. I hit a fence. I was six. Scared to death."[44] Connie, who was three years older and faced her own worries moving into a cottage with eleven other girls, was called out to "calm her brother down." Many former students described the difficulty of being placed in cottages apart from their siblings, but the adjustment could also be difficult for children who did not have siblings and were suddenly confronted by many people in that role. Kevin '88 described the experience: "I went from not having any siblings to having twelve siblings. And then there's the whole hierarchy, just think about it,

Girls showing their family spirit, circa 1999.

the whole social growth that you need to go through."[45] Despite their initial fears, many students quickly came to view their cottage mates as siblings and the larger Scotland community as family.

House parents played an important role in Scotland's effort to create homelike family relationships. While house parents were mostly women, in later years, a few men served in the cottages, and men always supervised the large line. In the late 1960s Superintendent Reinecker hired some married couples as house parents, but this initiative ultimately proved too costly and did not last long.[46] In the cottages for younger children, house mothers often received assistance from two older girls who had their own rooms in the cottage and helped with cooking and childcare. Not surprisingly, students' experiences with house parents varied considerably. Shirley '56, for example, said she had many "wonderful" house mothers. She fondly recalled playing games and doing the Sunday crossword puzzle with one of her house mothers and further emphasized the point by saying, "You felt like you were their child. It's just the way it was."[47] Agnes '71 stated that even though she and her friends "hated" some of their house mothers, she adored one in particular who taught her how to crochet and reminded her of her grandmother. Agnes said, "She would put her arm around me when I was sad. She just would give me the comfort that I thought a mother was

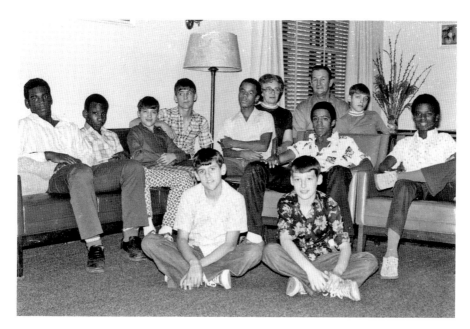

Boys with their house parents, circa 1970s.

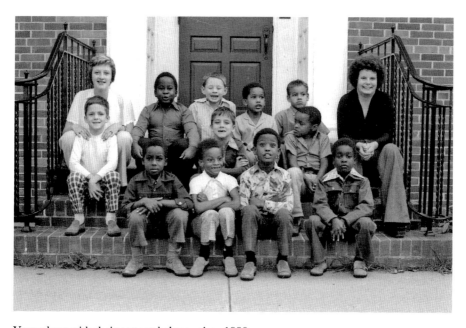

Young boys with their cottage helpers, circa 1980.

supposed to give you."⁴⁸ Describing his experiences with George Croutz '70, a dorm counselor supervisor known to generations of Scotland students as "Satch," Kevin '88 said,

> *He* [Satch] *is Scotland School. He did everything, but he was a large line supervisor when I was here. He's the kind of guy who could tell you you're screwing off, but, at the same time, if you did something good, he was in your corner…hanging out and cutting up with you. He helped keep the place on an even keel. You can't live in a school like this without people like that.*⁴⁹

On a similar note, Margaret '69 noted that students were usually closer to each other than to their house mothers, but she described one whose generosity was memorable to her. "Mrs. G———. I think that was her name. My senior year. She would buy us material to make prom dresses right out of her own pocket. She never asked. If she thought we needed something or if she saw something that we liked, she bought it."⁵⁰ Nancy Wright, who served as a house parent from 1980 to 2003, likely spoke for many house parents when she said "It made me feel good when they [students] trusted me and knew they could come to me with questions."⁵¹ While not all house parents could purchase items for the children in their cottages, many engaged in simple acts of generosity and kindness.

Other former students portrayed house mothers as being so busy with implementing discipline and meeting students' basic needs that they had little time for nurturing. Bill '58 pointed out that students did not receive much affection, and this may have been the school's one shortcoming from his perspective, though he was sympathetic to the challenges for house parents. He explained, "Well, there was some camaraderie there, as much as there could be. Not really any affection. There were fourteen or fifteen kids in there. It was difficult. Most of the time she was busy correcting whoever was bad, or whatever. Didn't really give them time to, you know."⁵² Some alumni reported difficult or distant relationships with house parents and highlighted how challenging the role could be given the resistance many students felt in their first years at the school. Generational and cultural differences between house parents and students also caused conflicts at times. Taajudeen "Taaj" '08 explained how students sometimes felt disrespected or misunderstood by house parents. He recalled "[house parents] telling us to turn off the TV just because we were watching rap videos. They would think that would corrupt us toward school or whatnot."⁵³

Not surprisingly, tension between students and house parents stemmed from feelings of being disrespected or unappreciated on both sides. In some instances, house parents, in addition to facing resistance and normal, age-appropriate rebellion, felt under attack by students and unsupported by the administration. In 1991, for example, SSVC house parents, with support from their union, the American Federation of State, County and Municipal Employees (AFSCME) Local 2356, alleged that they had been "verbally and physically assaulted by students" and suggested that discipline was breaking down at the school.[54] Frank Frame, who served as interim superintendent at the time, explained that his administration sought to move the school away from a physical discipline model and more toward a consequences-based system with rewards and incentives for good behavior. Frame and his staff provided training and professional development for both house parents and faculty focusing on positive discipline and cultural understanding.[55] Based on her experiences as a house mother, Nancy Wright suggested that children sometimes took out their frustrations, especially over not seeing their families, on house parents, but that positive relationships could usually be established when house parents received training and support.

Whatever their relationships with house parents and other adults, children at Scotland frequently came to rely on their new siblings for comfort and security. While several alumni said they lost touch with most classmates after graduating and some reported having been picked on and bullied at the school, the vast majority interviewed for this book described their fellow students as family. Some former students considered their bond with classmates to be even closer than one might find in a traditional family. One student who attended SSVC in the 1950s expressed this point at the last alumni reunion before the school closed: "These are my brothers and sisters, so I came from Oklahoma to be with them because it may be the last time. They were closer than the normal home is. The normal home doesn't have that many hours together."[56] Donna '64 also described her fellow students as brothers and sisters and said, "So it's like I come back to visit my family. On the road going home I'm usually a little depressed because it's like leaving home, leaving the family, the people that you know care about you."[57] When asked about the school, Randy '71 said simply, "She [Scotland] was my mother."[58]

While students often forged bonds with each other through struggles and hardships, they nurtured them with shared childhood fun and teenage antics as well. Many former students reminisced about swimming in the creek, ice-skating on the pond, fishing in warm weather and attending dances. They fondly remember holiday celebrations organized by various veterans'

Girls decked out in costume for the annual Halloween party, circa 1988.

VFW-sponsored Christmas party, circa 1980s.

organizations and their auxiliaries, including Halloween parties, for which Scotland students tended to go "all out" with their costumes; cottage Christmas parties; visits from Santa; penny scrambles; and Easter egg hunts. Not surprisingly, students also enjoyed recalling various forms of mischief in much the same way that adult siblings laugh over their undetected youthful misdeeds. George '45, for example, described how boys in the bake shop in the 1940s would engage in the occasional game of basketball with the dough or how they might sneak through the window into the bake shop after dark to gather up bread and peanut butter for a late-night stroll across the railroad tracks. At Christmas, each boy would ask for a different food item (e.g., baked beans, a ring of bologna and so forth) in preparation for their own makeshift parties.[59] Many students described how they would travel through the school's tunnels, designed for pipes and wiring, to see one another secretly and how they would carry on the time-honored traditions of short-sheeting beds and putting toothpaste on the hands of sleeping friends while attending Camp Legion in the summer. One former student even described how he and a group of friends commandeered a school tractor and drove it into Chambersburg, five miles away, on a Saturday. In telling these stories, alumni conveyed that Scotland students, like all children, simply wanted fun and normality in their daily lives. For them, this usually meant turning to each other. Perhaps this is why, decades later, some SSVC alumni still refer to one another as "kids"—an unspoken tribute to a shared childhood.

3
Discipline, Military Tradition and Work

Few images of the Scotland School for Veterans' Children are more iconic than those of young students parading on the oval in full dress uniform. While the school had no direct ties with active branches of the armed forces and never required graduates to serve in the military, it would be difficult to overstate the extent to which military culture and tradition imbue Scotland's history. All nineteen Scotland superintendents were men, and all but one served in the military, the majority in combat operations. By Pennsylvania law, five members of the Grand Army of the Republic, an organization for veterans of the Union army, served on the Soldiers' Orphans Commission, tasked with establishing the school in 1893. Even when a board of trustees replaced the commission in 1923, veterans continued to be well represented on the board. Scotland's leaders believed, by and large, that certain aspects of military life could be applied well to a setting for orphaned or destitute children. They sought to instill values of hard work, self-sacrifice, order, discipline and obedience.

General Smathers, superintendent from 1925 to 1940, especially focused on this aspect of the school by solidifying and expanding long-standing military influence and discipline practices. As both an educator and a military officer, he envisioned an efficient, well-managed school with a strong curriculum, competent staff and hardworking, well-disciplined students. His initial blunt and critical reports to the board of trustees made it clear that he planned to run a tight ship for students and staff alike. Smathers explained to the board that he would not hesitate to fire incompetent teachers unwilling to

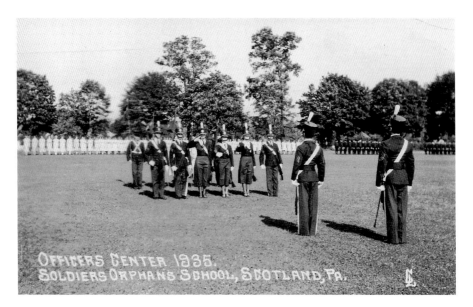

Officers parading on the oval, c. 1935.

conform to his program or to expel unruly students who might be a negative influence on others. Reporting to the board of trustees in January 1925, he said he would "not save one child to the detriment of ten others."[60] During his superintendency, students stayed in drill formation even when going to meals and classes so as to reinforce order and discipline.[61] George '45 described the orderliness expected during meals: "You'd march into the dining room, you'd stand there until Cappy Schlindwein or Cap Heckler would say, 'Be seated,' and you would sit down and you didn't open your mouth. You opened your mouth, you had to stand up. You were allowed to talk after a certain period of time when Cappy would ring a little bell."[62] Edie '41 also remembered the pervasiveness of bells: "Everything was by the bell. The bell would ring for you to get up, the bell would ring for you to go to meals [and] the bell would ring for you to go to school."[63] Students in this period had few choices about how to conduct themselves in their daily lives, and strong discipline prevailed.

Approach to Student Discipline

Smathers's expectations for discipline and his belief in absolute respect for authority reflected the position of most early military leaders at Scotland,

including Cap Heckler, one of the best-known figures in SSVC history. Heckler graduated from the school in 1923 and came back to serve, first as a military instructor during Smathers's superintendency and later in a variety of roles, including assistant superintendent and, briefly, acting superintendent, before retiring in 1965. Students who attended Scotland during Heckler's tenure likely have a Cap story to tell. They might talk about his softer side—how he played follow the leader with young children on the playground and offered support and well-timed advice to students of all ages—or about his love and devotion to the school. In addition to these traits, many former students recall his approach to discipline. Heckler and Smathers, influenced by their military training and the cultural norms of the day, firmly believed students needed strict discipline in order to develop properly. They carried out this discipline in a variety of ways.

By the early 1930s, Smathers had introduced a merit/demerit system at the school that allowed students to earn privileges, such as trips to Chambersburg for good behavior, or lose privileges, such as field trips and recreation time, for breaking rules.[64] Versions of this approach remained intact for much of the rest of the school's history. In some cases, school staff used work to discipline the children by assigning an extra work detail in response to a minor infraction or by assigning tedious tasks intended to teach a lesson. For example, several former students remembered the dreaded assignment of digging dandelions out of the large, grassy oval in front of the school's main building with a butter knife. As an added nod to military tradition, staff sometimes required a student to walk laps around the oval for extended periods of time while carrying a rifle.

During later periods, according to Margaret '69, house mothers often required students to write sentences for breaking cottage rules. She explained, "If you did something really stupid, you always had to write. A lot of the house mothers made you write one thousand times or one hundred times 'I will not do this.'"[65] In the 1980s, Superintendent Calverase, using a model from West Point, implemented a graduated class system in addition to demerits. In this system, rule infractions were designated by class, with class one offenses being the least serious and class five the most. Class one and two offenses resulted in loss of play time, television restrictions or extra chores, whereas more serious ones resulted in suspensions or loss of vacation time. House parents could only determine discipline for class one and two offenses; more serious offenses required consultation with administrators.[66]

School leaders, at least up until the mid-1990s, also used varying degrees of corporal punishment to ensure obedience. Corporal punishment,

practiced throughout the Pennsylvania orphan education system in the nineteenth century and considered standard practice in homes and schools, stemmed from long-standing beliefs about the connection between strict discipline and moral behavior. Using biblical arguments (e.g., spare the rod, spoil the child), parents and educators claimed to act in the name of love as they sought to control children's behavior and "break their wills" through the use of spanking, whipping, slapping and deprivation.[67] Despite admonitions from some individuals about the harmful effects of excessive physical punishment, the practice continued in many homes—and certainly in many boarding schools serving as homes—through much of the twentieth century. In interviews, SSVC alumni talked freely about the school's strict discipline system, and the vast majority described corporal punishment as standard practice during their time there. As with other aspects of the school, they viewed corporal punishment differently, often depending on their own experiences with it.

Some alumni described the practice as strict but fair and noted that only students who failed to follow the clearly defined rules ever received physical punishment. These individuals talked more about the merit/demerit system and tended to emphasize that teachers and administrators acted with care and in the students' best interests. They recalled firm discipline but all within the context of compassion and a desire to provide students with structure. Most of the alumni expressing this point of view had themselves experienced little to no corporal punishment at Scotland. Lisa, who attended Scotland in the 1980s, described it this way: "The discipline you think of, getting your butt spanked and that kind of stuff, it wasn't that. It was structure. It was you got up at six o'clock and you brushed your teeth and you put on your detail clothes, you ate breakfast….The whole structure is disciplined."[68]

A second group of former students described corporal punishment in a matter-of-fact way, expressing the viewpoint that it was "just how things were done" and that students knew the consequences of their actions. These individuals, many of whom said they learned their own lessons from brief encounters with corporal punishment, talked freely about the lack of restrictions on hitting students and the widespread use of paddles. George '45, describing the actions of one school administrator, put it this way: "He used to carry a paddle up his sleeve, and boy if he saw something, that thing would come out and 'whack!' It was made of plaster of Paris. It wasn't something that would break."[69] Regis '49 described his experience with an administrator this way: "He had a paddle, and he basically beat your back end. To me, under today's standards, it would be called brutal because

you can't do anything today."⁷⁰ Frank, who graduated in the early 1970s, described similar experiences: "Well, back then it was permissible. If a kid misbehaved, you whomped his little butt. I didn't care for that."⁷¹ Kevin, a 1988 graduate, said that there was "never any physical violence, but you got paddled. I can remember that was a big thing. The supervisors would have their own special paddles."⁷²

Former students also pointed out that both boys and girls received corporal punishment and that it could take many forms in addition to the paddle, including slaps and hits to the face. In one incident reported to the trustees in May 1952 by Cap Heckler, who was serving as acting superintendent, five boys left the school during the week of January 20, 1952, went home and reported that they had been "beat up" by a teacher at the school. Heckler blamed their bad behavior on the negative influence of construction workers at the school and explained what happened in this way: "It was necessary for a teacher in charge of the boys' dormitory to slap several boys because they resented authority."⁷³ Heckler expelled the boy considered to be the ringleader and never refuted the boys' account of what happened. Leadership at the time considered the teacher's response justified.

A small number of former students interviewed for this book described the corporal punishment at Scotland as extreme and, in some cases, abusive. One student from the 1960s described being "smacked" and kicked by a school official and having her hair pulled so hard that the memory of it affected her into adulthood.⁷⁴ Richard '64 described a scene in which he and a friend were called out of a bathroom by an administrator: "So we came out, and he literally beat that boy. I've never seen anybody hit a wall like you see in cartoons."⁷⁵ Both of these individuals indicated that these kinds of incidences were routine at the school for many students, especially those who did not have the favor of school staff. Most former students did not elaborate on corporal punishment practices in their interviews and did not provide specific examples in their descriptions, but many of them used the words "harsh" or "extreme" as they recalled corporal punishment at Scotland. Several said common practices then would be considered "abusive" today. Teachers concurred with these descriptions but noted that extreme corporal punishment was more likely to come from administrators or housing supervisors, especially in the large line (known as Januzzi Hall in the later years) than from teachers.⁷⁶ According to students from the 1990s and 2000s, corporal punishment at Scotland had been mostly eliminated by the mid-1990s. They were more likely to receive rewards for good behavior or verbal reprimands and restrictions

from privileges for violating rules.[77] Administrators still expected students to demonstrate respect for authority at all times, but they also established a discipline committee to give students a voice and make consequences more of learning experiences than punishments.[78]

One former student, a 1991 graduate who generally supported the school's strict discipline policy, raised the issue of race when addressing the use of corporal punishment at Scotland, noting that during his time, most of the students were black, while the teachers, administrators and coaches were white. An African American who came to the school as a first-grader, he recalled his first impression of physical punishment and how it never fully left him. "My first bad experience here was someone being able to beat me who wasn't my parent. So I'm not seeing nothing but the opposite race putting their hands on me. So that was not a good thing for me when I was young. The more I became older, it was always like I had a bad taste in my mouth about that, and I never let it go."[79]

This former student noted that many of his classmates urged him to "just let it go" but that he was not able to do so until many years after he graduated. Interestingly, like a few other interviewees, he believed that after 2000, the school became too lax with its discipline. He continued to think, however, that young black students would have been more receptive to discipline administered by black adults.

In addition to race, gender sometimes played a role in how staff administered discipline. As previously noted, all Scotland superintendents were men, most with military backgrounds. The same could be said of many of the school's principals. Traditional gender stereotypes often prevailed among administrators, and according to former students, it was not uncommon for girls to be held to a higher standard of moral behavior. Sally '65 provided an example of this when describing an experience she had as a middle school student with Cap Heckler, a man whom she held in the highest regard. After two male students got caught sneaking (uninvited) into Sally's cottage to see her and a friend during the night, Cap called the two girls in for a lecture on moral behavior despite the fact that they had not invited or encouraged the boys to come.[80] Kaye Shearer, a longtime physical education teacher and coach hired at Scotland in the 1960s, recalled many similar incidents in which administrators held girls but not boys accountable for troubling behavior. She witnessed this double standard on one of her first days as a coach at SSVC when an administrator spotted a boy kissing one of her field hockey players after practice. He called in Coach Shearer and reprimanded her for not "controlling" her girls, while the boy's behavior

and his presence in an out-of-bounds location remained unaddressed.[81] In interviews and conversations, many Scotland alumni and former staff indicated that gender disparities in discipline reflected a broader issue of gender inequity at Scotland.

Military Training

Just as discipline measures such as the merit/demerit system and corporal punishment practiced in the 1930s and 1940s continued at Scotland for several generations, so, too, did the belief in military training as a tool for building self-discipline among students and for managing their behavior. From its inception in 1895, Scotland had an active military department to promote physical fitness, organize drills and parades and teach day-to-day military practices. According to the following description of military training, published in a Scotland School guidebook in 1936, students learned important lessons by "paying the price" for failures in military training:

> *It seems at first to the student that military training is made up of countless impossible requirements. If he forgets his trench cap for inspection he pays the price. If he turns his head in ranks, forgetting he is at attention, he pays the price. If he fails to hear the bugle, and is late for formation, he pays the price. These things cause the student to be obedient, alert, and punctual.*[82]

The school's military organization, which by the 1930s contained an infantry battalion of three companies with a full complement of student commissioned and noncommissioned officers, reinforced obedience. While all children, boys and girls, between ages eight and nineteen participated in military training, the younger children learned obedience by taking orders from their superior officers as well as from faculty and staff. Students were never to talk back or argue under any circumstances. Older boys could advance through the military ranks, honing their leadership skills in the process.

Some of Scotland's military rigidity slackened a bit in the post–World War II era, but the basic system with student officers, dress parades on the oval and battalion parades and performances in the community continued until 1981, when Superintendent John Jannuzi introduced the JROTC at Scotland. SSVC required all students in grades eight through twelve to

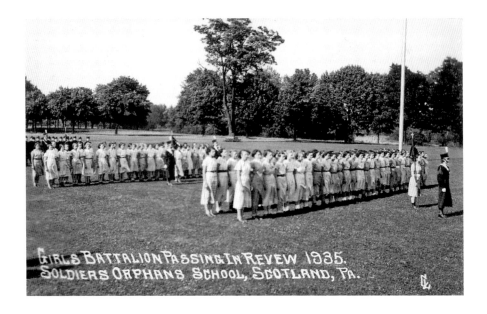

Above: Girls' battalion standing at attention, circa 1935.

Left: Norman C. Waters Jr., pictured here in 1990.

Discipline, Military Tradition and Work

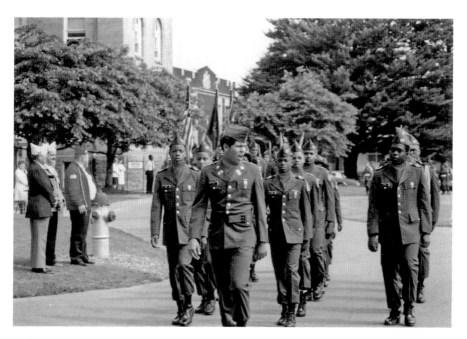

JROTC parading in the 1984 graduation ceremony.

participate in JROTC, including girls, who often thrived and performed at the highest levels. As with the previous system, this new program focused on teamwork, self-discipline, leadership skills and physical training rather than recruiting students for military service. SSVC encouraged students to consider the armed forces as a viable option after graduation, but there was no expectation that they do so. Up until a few years before the school closed, students continued to have mandatory drill or physical training (PT) in the morning before classes began, but by the late 1990s, that had changed. Taaj '08 explained that by the time he was in JROTC, only those individuals who joined the Raider team participated in mandatory PT every morning.[83]

The Raider team—prominent and highly successful at the school during the 1990s and 2000s—added to the long history of Scotland's competitive drill and rifle teams. Students who joined the Raiders trained for competition in PT and other skills such as rope bridging, land navigation and first aid. They and other JROTC members also attended a summer camp at Fort Indiantown Gap, near Annville, Pennsylvania, to hone their skills. Harriet, who would have graduated from Scotland in 2011, described both her Indian Town Gap training and her Raider team experiences as excellent preparation for her future military service.[84] The

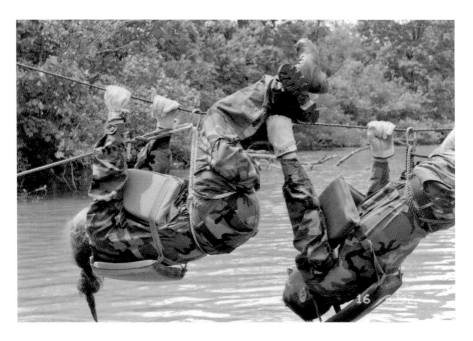

Above: Summer training at Fort Indiantown Gap, circa 1997.

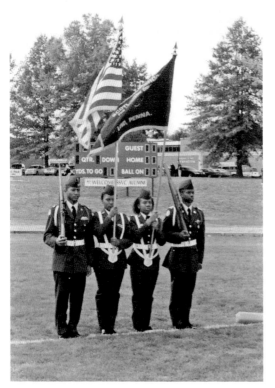

Left: Color guard on Heckler Field, homecoming weekend, circa early 2000s.

Discipline, Military Tradition and Work

details of twenty-first-century students' military experiences may have looked different from what Smathers imagined in the 1930s, but the essence remained the same.

For many former students, the regimented schedule and attention to order and detail carried over into their adult lives. Once out of school, some continued to eat meals at the same time every day and insist on clean and orderly homes, expectations not always embraced by their family members. Connie '55 described the challenge of adjusting expectations from those established at Scotland to what one might reasonably expect in a traditional family environment.

> *You know, what is normal within a family, a small family? My expectations for everybody was neat and clean. We were that way. You didn't leave until everything was clean and neat. I'm still that way today. My granddaughters laugh at me because of their rooms. I am so used to putting everything away in its place. I never leave my house unless it's in order. I still do all that.*[85]

Regis '49 explained how the influence also extended to conduct and appearance: "What I learned here, it followed me to this day: how you dress, how you conduct yourself, how you look. You had to groom yourself 'cause every hair had to be in place."[86] Tedd '60 described a similar long-lasting effect of Scotland's expectations. He married a fellow Scotland graduate and explained the school's influence on their approach to strict parenting.

> *We certainly did everything the same way because we were here together, so everything was kind of pretty much standard. I certainly think I was much too strict on my children. I think that was because of the way I was raised, essentially, here. There are probably things that I would have done differently had I been a normal parent, if there is such a thing, but maybe not. But I will tell you that when we would go out...we would get compliments at restaurants about how well behaved the children were.*[87]

Despite their struggles with the rigidity as children, many other alumni described conducting themselves according to strict schedules as adults and raising their families with firm guidelines and good manners.

Working at Scotland

Just as the staff at Scotland expected students to conform to schedules, so, too, did they require hard work from the students as a form of discipline. Even the youngest children participated in daily work details and took care of their own personal effects. George '63 illustrated this point when he recalled what happened when the school day ended and older students went to sports practices.

> *At three o'clock you went up to the cottage area, and they gave you a little bit of time to play, so you went outside and played. You took your uniform off. They had brown shorts and a gray shirt, buttoned down the front. After that you came in—they had the scrub boards, you don't see them anymore—you'd change your underwear, wash your underwear out with yellow soap, washed your socks out every day.*[88]

Younger children also kept their rooms cleaned and helped with other tasks, such as cleaning the cottages, carrying food baskets and mending clothing. In addition to these daily chores, older children worked in the kitchen preparing meals for the dining hall or helped to prepare food for younger children living in the cottages. Several female alumnae recalled what seemed like an endless task of preparing potatoes. When Margaret '69

Boys carrying a food basket to their cottage, circa 1953.

described working as a helper in the cottages for younger children, she said that she generally enjoyed the experience.

> *The only thing I didn't like...[was] when we would do potatoes, we had to peel like two gallons. My daughter always says, "Make real mashed potatoes," and I say, "If you'll peel the potatoes, I'll mash them." It's awful, I don't eat French fries, if it requires peeling a potato. That's probably the only thing I don't do.*[89]

Preparing meals for twelve or fourteen children in a cottage approximated the kind of family living that cottage advocates had originally envisioned back in 1895 more than performing the same tasks in a large dining hall, but it still required far more work than one would have found in a traditional family.

In addition to taking care of their rooms and personal effects and helping to prepare meals, the children usually spent Saturday mornings readying themselves and their dormitories or cottages for inspections. Agnes '71 recalled a typical Saturday morning:

> *But I remember Saturdays was our cleaning day and that would be cleaning everything: basement, everything, bathrooms. We would take pots and pans out on the little hill, because over at cottage 40 there's that, we used to call it the hill, and we'd take all the pots and pans out there with our Brillo pads and we'd sit and scrub till they shone. They had to shine! And for some reason the pots they had here, they would shine.*[90]

Agnes was one of several students who mentioned the scrubbing of pots and pans. Tedd '60 recalled how this task put the work he and his co-workers did later in life into perspective:

> *What I did see was, man, work ethic. I taught people as an adult, they said, "Oh, I have to go do this?" and I said, "Gee, have you ever sat for four hours as a nine-year-old and scoured fricking pots and pans 'til you could see your face in them?" "What, what?" "Yeah, that's how I spent my Saturday mornings." You'd be sitting there, you'd be shining at the same pots for an hour, you take it in and they say, "Not good enough," and you go back out and you start again. "Have you ever buffed a floor with your feet?" "What!?" Even in the military, nothing bothered me, it was like, "Go do this, go take this ladle and dip out the cesspool." "Okay!" It was just not a big deal.*[91]

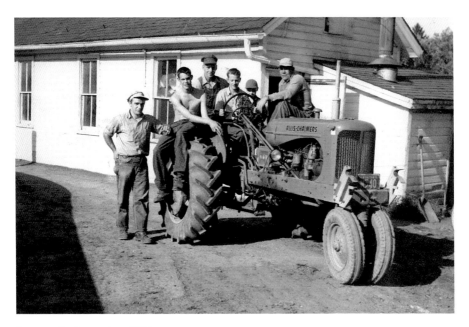

Boys on the farm, circa 1954.

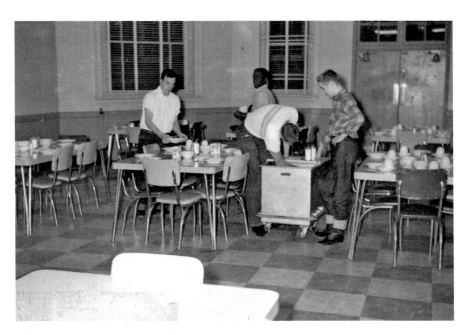

Dining room preparations, circa 1950s.

Discipline, Military Tradition and Work

Tasks such as scrubbing pots and pans, cleaning and preparing meals gave Scotland graduates a work ethic they often commented on and valued years later. Many described hating the work at the time but later appreciating the values they derived from it.

On top of individual work detail, students played a significant role in the day-to-day operations of the school. As Connie '55 stated, "You have to understand, our students maintained this place. They did everything."[92] Up until the mid-1960s, when the farm was scaled back, a small handful of students helped support the paid staff with baling hay, milking cows and butchering.[93] Students not involved in extracurricular activities helped maintain the campus by pulling weeds and doing other odd jobs after school. Randy '75 reported that these jobs might include cleaning the "recky" (a wing added to the main building in 1928 as additional housing space) or student lounges.[94] Many students prepared and served family-style meals in the dining hall. George '63 recalled the process:

> *We went in to eat, and there were certain guys every week, we'd get called waiters. You would come in and sit down…[then] stand up, they'd say the prayer, somebody would say the prayer, you sit down and they brought the meals around the table like in a restaurant, set it on the table, family-style. From six o'clock till twenty after, you had to eat your meal. Even if you weren't done eating your meal, the waiter would come and clear the table off. Then they brought dessert in. Whatever it was, they gave you ten minutes to eat dessert. Then you got up. They had guys who would clean the floor, wiped the tables off. Before we ate, the guys who waited on the tables ate before we did, see, so they could serve the rest of the guys.*[95]

In addition to working on the farm, maintaining the campus and helping to prepare and serve meals, the work that students did in the trades program often directly benefited the school. This was especially true in areas such as mending, tailoring, baking and printing (see chapter 4).

Support from Military Organizations

In addition to their effect on the daily lives of students and staff, Scotland's strong ties to the military influenced the school in another significant way. From its first day to its last, SSVC depended on Pennsylvania veterans'

Stadium scoreboard replaced by the 40 & 8 Grand Voiture of Pennsylvania in 2004.

Amphitheater, dedicated by the American Legion in 1950.

organizations and their auxiliaries for support. The school might have survived on state funding alone, but it never would have thrived in the ways that it did or offered its students the same kinds of opportunities and experiences without the constant help from these groups. Scotland students felt their presence on a daily basis. First, they had many visual reminders. Veterans' groups funded or helped to fund numerous physical structures on campus as well as a variety of plaques and monuments. Among many others, these included a stadium scoreboard donated by the 40 & 8 Grand Voiture of Pennsylvania and replaced in 2004, a large clock on a brick base in the cottage area dedicated by the Grand Army of the Republic in 1961 and an impressive memorial amphitheater dedicated in 1950 by the American Legion of Pennsylvania. In addition, they funded everything from playground equipment, band uniforms and library books to games and televisions for the cottages.

Even more important than their contributions to the physical plant, veterans' organizations made it possible for Scotland students to enjoy many activities and privileges they may not have had otherwise. Each year, the VFW provided much-anticipated Christmas parties for the children, complete with Santa Claus and gifts. Veterans from Lebanon County gave "tons of bologna" and sponsored penny and peanut scrambles for the entire student body. Veterans' groups also sponsored annual Easter egg hunts, picnics at the Willow Grove amusement park, military balls and Halloween parties; funded regular field trips to Washington, D.C., and, on a few occasions, trips as far away as Atlanta, Georgia; and provided everything from class rings and yearbooks to luggage and clothing for graduating seniors. Each year, they funded dozens of awards and scholarships in support of education and training beyond high school.

In addition to donating goods and services, veterans' groups interacted on a regular basis with SSVC students whom they recognized as the sons and daughters of their comrades. They visited campus frequently and came out in full force for special events, such as graduation. In some cases, they invited children who had nowhere else to go to stay with them over the summer or during school holidays. For many years, the school assigned each student a "Legion Lady" from the American Legion Auxiliary, and these women took a special interest in their assigned students, writing to them or giving them special treats. Nicki '91 described the importance of these women:

> *The VFW brought us Christmas gifts every year. We would write a letter with what we wanted, and before the Internet, we had to find these gifts in*

A visit to the cottages from Santa and helpers, circa early 2000s.

catalogues. The Legion Ladies would also come around Christmastime and spend time with us and bring us gifts. I remained in contact with my Legion Lady through graduation and until she passed away. I think back on that and how special it was that those ladies did that for us.[96]

Graduation ceremony, 1999.

Finally, most of the state veterans' organizations maintained Scotland School committees and designated budget lines for the school as a matter of course.[97] As a result, they contributed hundreds of thousands of dollars to the school over the years. As a specific example, from 1988 to 1990, veterans' organizations donated $65,483.73 to special funds for Scotland School. This did not include any money given to individual students or used for special activities such as Christmas parties.[98] Scotland would have been a very different school without the unflagging support of Pennsylvania's veterans.

4
The School Experience

When Connie Smoker graduated from Scotland in 1955, she headed to Philadelphia for nursing school and ended up taking a few science courses at the University of Pennsylvania. She had excelled academically at Scotland but still wondered if she would be prepared for rigorous college coursework. Connie need not have worried. Describing her experience more than fifty years later, she explained that she had gained two important advantages from her Scotland education: good study habits and an excellent science teacher. She described it this way: "So I go to chemistry at UPenn and I am past all the stuff. My classmates used to get mad at me because I was an 'A' student but I couldn't help it. I had better prep. They went through the same courses, but they didn't study and here you had to. We had required study hours every night."[99]

Connie is one of many former students who excelled in college and went on to pursue a variety of professions in medicine, law, education, business and engineering, among others. Some alums distinguished themselves at the country's most selective colleges (Columbia, Cornell, Howard, Lehigh, the University of Pennsylvania and West Point) and advanced in prestigious careers. A college preparatory curriculum geared toward Scotland's most advanced students, however, comprised only a small portion of the school's overall academic program from 1895 to 2009.

From its inception, Scotland offered a basic academic education, a foundation in trades training and a grounding in moral and civic education to all students, regardless of their intellectual aptitude. In addition, recognizing its students' limited access to outside resources, the school

provided many opportunities for experiential learning, often through field trips and outdoor education programs guided by faculty and staff. Initially, the academic curriculum remained fairly limited, and most Scotland graduates took up trades or served in the military after graduation. In the late 1920s, the school began marketing its curriculum as one with three tracks: vocational, commercial or college preparation. The vast majority of students pursued the first two options. Beginning in the second half of the twentieth century, as college enrollment in the United States expanded, Scotland's curriculum evolved to incorporate more rigorous academic coursework. By the time SSVC closed in 2009, the traditional trades program had been significantly curtailed, and the majority of graduates planned to attend two- or four-year colleges.

Academic Program

Although Pennsylvania did not pass its first compulsory attendance law until 1895, the same year Scotland opened, common schools had been well established in Pennsylvania for several decades by that point.[100] Using the common school curriculum as a framework, Scotland provided all students basic math, reading, writing and geography up through an eighth-grade level. For more advanced students, Scotland offered algebra, civil government, natural philosophy, geometry, literature, rhetoric and bookkeeping.[101] All students took required vocal music classes. By the early 1920s, the curriculum also contained four years of health and social studies, including a course titled Problems of Democracy for seniors and three years of French or Latin.[102] To support the academic program, the school established a library early in its history and, by the mid-1920s, reported having four thousand volumes, most of them donated by the Ladies Auxiliary of the American Legion.[103] During the early years, all secondary students spent three hours in academic classes, three hours in industries and one evening hour in study hall.[104]

Scotland's basic academic program began to change in 1924 when newly appointed superintendent Blaine Smathers hired J.G. Allen as principal. At the first board of trustees meeting of the 1924–25 school year, Allen explained that he and Smathers intended to make the academic curriculum at Scotland comparable to any other high school in Pennsylvania.[105] To this end, Allen sought guidance from the Pennsylvania Department of Public Instruction (DPI) to improve and update the academic program. Allen's initiatives

paid off on January 8, 1928, when Scotland earned official accreditation from the state along with authorization to begin issuing standard high school diplomas.[106] In the years immediately following the accreditation, administrators continued implementing recommendations from the DPI. They, for example, established a new bookkeeping and accounting system to improve accuracy and efficiency in the school's management and partnered with Shippensburg University to design progressive professional development workshops for faculty.[107] Perhaps most importantly, they moved forward with plans to construct a modern school building that would provide much-needed space for existing programs and facilitate the addition of new ones. When the building opened in 1933, it included additional classroom space, a section set aside for a new homemaking department and an expanded library, stocked with shelves and furniture built by Scotland's own students.[108]

In addition to program initiatives, Smathers and Allen employed smaller strategies to raise academic standards. They focused specifically on students' communication skills. For example, in the spring of 1928, Scotland held a "Good English Week" to demonstrate the value of speaking and writing well in everyday life. Administrators plastered posters with grammatical errors and corrections across the school, and students performed a play highlighting dos and don'ts in communication.[109] A decade later, Principal Allen began offering a weekly one-dollar cash prize to the individual in grades three through eight who wrote the best letter home. In the estimation of at least one student writer, Mary Miller, the contest significantly improved letter quality.[110] With these initiatives, the administration hoped to raise academic expectations.

As an accredited school under the direction of the DPI (later renamed Pennsylvania Department of Education, or PDE), Scotland's academic program conformed to state guidelines and regulations. In the fall of 1938, Scotland hosted the first meeting of the Franklin County Teachers' Association, with over four hundred teachers in attendance. This group, a county affiliate of the Pennsylvania State Education Association formed in 1852, served as a vehicle for professional development and salary negotiations.[111] Scotland teachers met state certification requirements, and students took all state-required exams and courses for graduation. In accordance with state policy, Scotland issued high school diplomas only to those students completing the mandated four-year course; all others received a certificate upon exiting the school due to age.[112] Although Scotland never offered the array of high-level courses found in many large public schools,

the curriculum expanded over time to include advanced math and science classes, including chemistry and physics. In addition, the school often provided at least one foreign language, with French and/or Latin being offered intermittently from the 1920s through the early 1950s. Beginning in 1953, Scotland added Spanish and offered that and, at various points, French until the school closed.[113] In the 1980s, in an effort to make the curriculum more culturally relevant to black students, social studies teacher Gary Fishel added an elective on African American history to the course offerings.

In addition to expanding the curriculum, Scotland became increasingly responsive to the needs of students struggling academically. Prior to the late 1960s, students might have received help from individual teachers or fellow classmates, but the school did not fund formal remediation or tutoring programs. Frequently, especially in the first several decades, weak students took extended shop hours in place of academic work.[114] In the years following the 1965 passage of Title I, Scotland used federal funds for programs designed to address, in a more structured and intentional way, the needs of students performing below grade level. School officials primarily used the money to establish a summer school program, a formal guidance department, innovative reading and mathematics labs, a tutoring program with Shippensburg University education students and an outdoor education program.

The guidance department launched in the fall of 1967 under Kenneth Katusin, who had been at Scotland for seven years as a social studies teacher and coach. According to an article in the school newspaper, the new department worked with students "concerning college entrance examinations, introducing students to the world of work, developing curriculum, and studying the social-scholastic problems of the school."[115] In addition to the guidance program, Scotland took special pride in its new academic labs, which opened in 1974 and allowed students to practice basic skills in a positive environment.[116] The Educational Development Center at West Chester State College (now West Chester University) provided curriculum resources, teacher training and other support services for this initiative.[117] Designed to accommodate small groups and individual students working at their own paces, the brightly colored rooms contained math manipulatives, visual representations, multimedia kits, mobiles, games and computer stations. The labs also provided time clocks, prompting students to clock in and clock out after each lab session. Time cards, designed to enhance motivation, recorded students' hours, skills and scores.[118] In addition to the labs, Title I money funded after-school remedial classes for second through

The School Experience

Guidance counselor Kenneth Katusin working with a student, circa 1990s.

ninth graders and tutors for students in first through eighth grade.[119] The school issued reports each year showing a range of modest to significant gains in students' test scores.

During Scotland's last few decades of operation, school recruiters used the school's academic program as a selling point to prospective families, especially in the Philadelphia area, where parents had concerns about the quality of public schools available to their children. Scotland's small class sizes, academic support programs and college preparatory curriculum appealed to parents looking for the best educational options. When Kisha, who attended SSVC for several years in the late 1980s and early 1990s, returned to public school in Philadelphia, she recalled, "I was pretty much ahead of most people in the public system. I learned how to study more."[120] Taaj '08, crediting both his teachers and his advanced coursework, considered himself better prepared for Shippensburg University, the college he entered after graduation, than he would have been had he stayed in Philadelphia. He described it this way:

> *I have a lot of friends in Philadelphia who had to go to community colleges to take chemistry or physics because they didn't have that or the advanced*

Scotland School for Veterans' Children

Students engaged in an elementary classroom, circa 1980s.

math. And my English teacher should have been called Professor Frey. He really advanced my whole vocabulary. Without him—writing papers, critical analysis within reading books—I would not know how to do any of that at college without his help.[121]

Many parents and students shared similar perspectives when they pressured legislators to keep Scotland open rather than have students return to their home districts. Even as the academic curriculum became more rigorous at SSVC, however, the school's trades program remained an important part of learning at Scotland.

INDUSTRIAL CURRICULUM

When Scotland was founded, very few students in the United States attended college, but the growing industrial economy required an increasing number of skilled laborers and office workers. With this in mind, school leaders prioritized industrial and commercial education programs designed to equip

The School Experience

students with marketable skills. Because none of the schools in the Civil War orphan education program offered a precedent for industrial training, Scotland educators had to design their own model. The commissioners considered several different approaches but, after visiting schools around the country, decided on a trades training approach for SSVC.[122] This model, similar to those in many European countries, tracked students into specific trades and then geared their training to that trade. In its initial years, when Harford, Uniontown and Chester Springs remained open, Scotland received the older students who selected specific trades for their final years of schooling. According to the superintendent's report for 1896, the girls' initial industrial curriculum provided training in stenography, typewriting, telegraphy, scientific cooking, dressmaking and general sewing (sometimes referred to as mending).[123] In 1896, the boys' curriculum included printing, woodworking and shoemaking, with plans to add a machine shop, a blacksmith shop and plumbing and pipe fitting. They could also choose to work in the bakery or laundry, and all boys helped with electrical work and machinery around the school.[124] By 1904, the school listed printing, tailoring, laundry, telegraphy, typewriting and stenography as options for both boys and girls.[125]

Students at Scotland gained practical experience in their trades by working at the school. Boys in the wood shop, for example, repaired everything from door frames to window screens and made basic furniture. On one occasion,

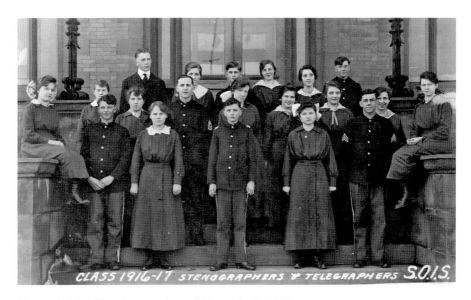

Boys and girls taking stenography and telegraphy in 1917.

they made twenty sleds for the children and on another made a large closet for football uniforms. During the 1910–11 school year, the boys constructed an impressive grandfather clock often referenced in school literature through the years and currently located in the Scotland School Museum. Through these projects, large and small, students put their skills to practical use.[126] Those in tailoring and dressmaking made school uniforms—dark-blue coats and light-blue trousers with a black tie and black shoes for boys, gingham dresses of varying patterns and separate uniforms for drill and physical education for girls. They also made new dresses for young women leaving the school due to age.[127] The baking department reportedly made four hundred to five hundred pounds of bread per day.[128] Once the commercial course became more established, girls performed clerical work, such as correspondence, filing and recordkeeping, in the school office.[129] Although critics of the trades training approach questioned the appropriateness of having students spend such a large portion of their days "working" in one specific area, educators at Scotland believed their students would benefit from leaving the school having mastered at least one trade.

In keeping with the academic improvements of the 1920s and '30s, the industrial program was overhauled in this period as well. Principal Allen required each trade program to develop a new detailed course of study. The DPI rewarded Scotland for its improved vocational program and brought positive publicity to the school in January 1937 by inviting twelve Scotland students to be among those demonstrating their trades at the Pennsylvania Farm Show.[130] The addition of a modernized trades building in 1939 allowed students to work on up-to-date machinery in a more spacious environment and to gain instruction in new areas, including electricity. In 1940, in one of Smathers's last acts as superintendent, he recommended that the basement of the school building be remodeled for a beauty culture program. He explained to the board that Scotland would only need to pay $500 toward the $1,700 project because the school could attain the rest of the funding through a Works Progress Administration (WPA) grant.[131] This new program kicked off for senior girls in January 1941 under the direction of Evelynne Miller. In 1942, students in the program committed to helping the war effort and adopted the slogan "Beauty for Victory," based on the belief that beautiful women improved soldiers' morale.[132] By the late 1940s, Pennsylvania contained eighty beauty culture schools, but Scotland's program was one of only seven allowing students to take a regular high school course while becoming licensed beauticians.[133] Scotland added barbering to the vocational program in 1946 and expanded it in 1966 with a modern six-chair barbershop.

The School Experience

Students working in the print shop in 1959.

Girls making school uniforms, circa mid-1920s.

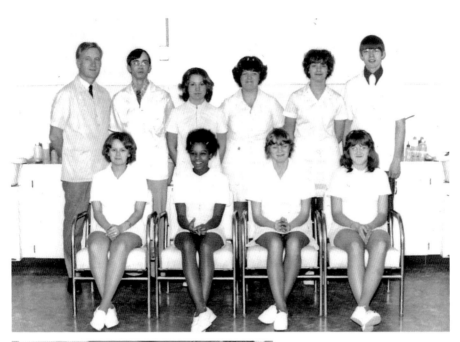

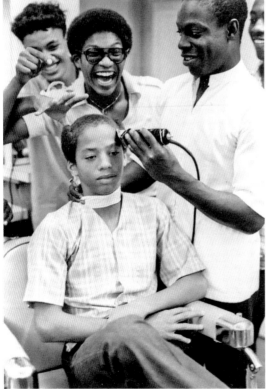

Above: Beauty culture students with their teacher, Leland Schaffer, circa 1970s.

Left: Students enjoying the barbershop, circa 1980.

The School Experience

When Allen became superintendent in 1941, he hired Charles Zinn from Penn State University to offer weekly training courses for instructors in order to keep them up to date on vocations and teaching techniques. Allen also established a new approach to "exploratories," which allowed junior high school students in eighth and ninth grades to spend time in different shops before choosing their primary courses of study for their last three years.[134] The exploratories model, in addition to helping students select their specialty area more wisely, gave all students basic training in more than one trade.

Many students who stayed at Scotland during the summer gained additional opportunities to explore different trades, as they helped maintain the school. Regis '49 described how this practice set students up to be more independent and self-sufficient upon graduation.

> *I would say that we were taught to sustain ourselves. Self-preservation. I worked in the bake shop in the summer; I worked in the print shop. I worked wherever we would go. I know that if it was a matter of going out and working in a bake shop, I probably could've did that because you learned how to roll your bread with two hands…same thing with working in the machine shop and so forth. After you got shocked a few times with electricity, you knew what that was.*[135]

There were, however, limits to this exploratory process, particularly when it came to gender. Shirley '56, who went on to a career in mechanics and electronics, including work on the Patriot Missile, thought she got an excellent education at Scotland but regretted that girls were not allowed to explore many of the trades, a limitation she found particularly frustrating given her interests and natural aptitudes. She completed the cosmetology program at Scotland, but, sadly, did not fully discover her latent mechanical talents until years later when she outperformed all eighteen male co-workers on a mechanical test for her job.[136] Sonia '89 recalled a similar gender divide in the 1980s in which boys might take trades traditionally geared to girls such as cosmetology or home economics, but girls could not take trades such as bake shop, electric shop or carpentry.[137]

From the Smathers/Allen era until 1991, when the trades program in its entirety went under review, the structure of the department remained the same. Administrators added particular trades (sheet metal/welding, auto mechanics, data processing) to the curriculum based on student interests, the job market and the availability of qualified teachers but left the model more or less in place.[138] All students, boys and girls alike, took exploratories

in eighth and ninth grade and then selected a specialty area for high school. For girls, and a smaller number of boys, this often meant choosing the commercial/business course, which grew in popularity from the 1920s to the 1980s. This program incorporated new technologies but generally included courses such as typing, shorthand, accounting and business math. The Commercial Club, established in the early 1940s with the purpose of adding interest to the business curriculum and enhancing the professional development of members, played an important role in promoting this aspect of the curriculum. Students who chose the college preparation curriculum still took the exploratories in eighth and ninth grades but then took more advanced academic courses in high school.

Many students who completed their trades training course at Scotland discovered talents and interests they used both at school and after graduation. Granville '41, for example, believes he got a job as a machinist due to Scotland's good reputation among employers and to his excellent training, which allowed him to get through a tricky hands-on interview.[139] David '75 found his career after completing the auto mechanics program. Speaking in 2009, he described his path after finishing the junior high exploratories: "Then I majored in auto mechanics, [and] I'm still a diesel mechanic. Matter of fact, the teacher in our class, he knew my interest in it. He went to somebody, and they donated a diesel truck to us down here. We actually got one in the school that I could work with."[140]

Sometimes students became so good at their designated trades they made names for themselves before ever leaving the SSVC campus. Sherman Price '81 is one such person. At a Scotland alumni event in 2015, a group of attendees talked in the most glowing terms about sticky buns perfected by Sherman, who was known around school for his excellent baking skills.

Experiential Learning

Because Scotland children lived on campus and often came from families with limited means to provide travel and enrichment opportunities, the school prioritized learning through experience in addition to learning in classrooms and shops. In the early decades, this most often occurred when students traveled to different parts of Pennsylvania or occasionally to neighboring states to give musical or military drill performances. In later years, field trips of this sort continued, but students, with financial help from veterans'

organizations, also visited historic sites (e.g., Gettysburg, Washington, D.C. and Mount Vernon) or went to special events such as the Shrine Circus in Harrisburg. George '63 recalled, "They used to take us kids to the flying circus. We'd load up the buses and go into Harrisburg. They'd feed us kids in their big dining room and give us hats. I looked forward to that every year."[141] In addition to entertainment, students sometimes traveled to conferences or participated in other off-campus leadership opportunities, such as Keystone State Boys' and Girls' camps and Junior Miss competitions. In 1998, several JROTC students gave speeches at the Keystone Area Chapter of Retired Officers' Association.[142] For many years, beginning in the mid-1980s, SSVC students attended black history month events at Shippensburg University and, in some cases, had their pictures taken with well-known African Americans, including meteorologist and *Today Show* host Al Roker and basketball legend Julius Irving.[143] In 1991, 1993 and 2002, groups traveled to Atlanta to visit historically black colleges and museums and memorials connected to the civil rights movement.[144]

The most extensive experiential learning emerged in the 1970s and 1980s with the outdoor education program. Frank Frame, serving as director of curriculum at that time, wanted to use some portion of SSVC's Title I funds to bolster academic skills while also giving students experiences they might not otherwise have. As Kaye Shearer, one of Frame's former colleagues who helped with outdoor education, explained, "Frank was real big on getting things for the kids. Not just an ice cream cone or something, but an experience."[145] Many SSVC students during this period came from urban areas and lacked opportunities to explore nature in the kind of sustained way outdoor education provided them.

The initiative contained three key parts. The first involved sending groups of students to Camp Legion for one-week environmental education camps held during the school year. According to Shearer, fourth, fifth and sixth graders attended camp one week, and seventh graders went a different week. Teachers traveled to camp each day to teach their classes. Support staff, house parents and one or two faculty members then stayed overnight with the children.[146] Shippensburg University students frequently served as counselors and instructors. Students participated in hands-on learning activities involving nature walks, bird study, plant identification, knots and lashing, soil organisms, stream study, gun safety and survival.[147]

Scotland geared the other two parts of the outdoor education program, namely backpacking and orienteering, toward senior high students. High school faculty took groups of ten to twenty students on weekend trips

Student exploring nature at outdoor education camp, circa 1970s.

either to Camp Legion for orienteering or to the nearby Appalachian Trail for backpacking. Teachers Ray McKenzie, John Chontos and Fred Boss developed the first orienteering trip, open to both boys and girls. They spent the three Saturdays prior to the trip at Camp Legion setting up the stations and developing the course.[148] The instructors divided students into teams and taught them how to use a compass, read a topographic map and pace themselves in a series of short competitions on Saturday. On Sunday, teams competed in a major event to find hidden markers in the foothills of South Mountain. Eventually, teachers developed a beginner orienteering course (two and half miles) and an advanced one (five miles). Although consistently popular with the students, these orienteering weekends occasionally proved dangerous, as the groups went out in all kinds of weather. Illustrating this point, Ray McKenzie reported that one young woman ended up with frostbite and had to be returned to school.[149]

As a second option, high school students could participate in backpacking trips on the Appalachian Trail. Angus Hamilton, a teacher and principal at Scotland, and Gerry Wilson, a physical education teacher, helped to organize this program, but several SSVC teachers participated over the years.[150] After instruction and preparation, students spent the weekend hiking the trail and camping overnight before arriving at Caledonia State Park on Sunday afternoon to be bused back to school. For students who

had never hiked or camped before, this proved to be quite an adventure. Kaye Shearer recalled,

> *I'm thinking about that group of kids, those first couple of classes. Those kids would sign up for something, first of all, to get away from campus to be very honest, but they would also say, "Miss Shearer, I will never get to do this again, and I want to know what it's like." Now, they'd be scared to death. Particularly backpacking because we walked the A.T. The dynamics were unbelievable.*[151]

Gerry Wilson, remembering how dark the trail seemed at night to teenagers accustomed to streetlights and urban neighborhoods, described how students would often burn their flashlights as long as possible to avoid the dark.[152] In addition to developing math and science skills, these trips fostered confidence within SSVC students and encouraged them to work as a team and confront their fears.

Moral Education

From its founding, Scotland emphasized morality and taught students to "do the right thing," as school personnel defined it. Students learned to have good manners, to behave courteously and to respect authority at all times. Beyond that, faculty and staff encouraged students to make good decisions and follow community expectations for honesty and integrity. Religion, deeply imbedded in school culture, played a key role in teaching students moral behavior. In the original orphan education program, superintendents assigned children to schools based largely on geographic location, but they also took into account the religious affiliation of the children and, when possible, placed them in homes/schools connected to their own religions. Schools not affiliated with any particular religion still provided Bible study and moral training. This nineteenth-century tradition of blending education and religion continued at Scotland. Even before construction of the first chapel in 1907, the school held Sunday afternoon services conducted by a local Lutheran minister.[153] Local priests conducted Catholic services on Sundays, and the school encouraged students to affiliate with local churches. In addition, students participated in daily devotionals and attended weekly Sabbath school classes.[154]

This religious emphasis persisted at Scotland even as some of the particulars changed. In the 1950s and 1960s, for example, it became common practice to give students the option of either participating in the chapel service on campus or attending services at churches in local communities. According to Jim '70, the school took two buses, one headed to Corpus Christi, the local Catholic church, and one to a variety of other protestant churches or the local synagogue, where students would be dropped off and picked up after services. When the new campus chapel opened in 1970, most students attended either the ecumenical service on campus or the local Catholic service. The relatively small number of students with parental permission to be excused from church spent that time in the school library or in the basement of the chapel. During Scotland's final three decades, several Muslim students attended. On Saturday mornings, an imam from Harrisburg came to Scotland and met with the students for prayer and study.[155] The school also encouraged Muslim students to celebrate Ramadan and accommodated all meal and dietary requirements.[156]

One of the best descriptions of the school's overall religious philosophy, regardless of time period, appears in the 1950 yearbook. Referencing a connection to Scotland's official hymn, "Faith of Our Fathers," it states, "No boy or girl is barred from our school on account of race, color, or creed and we firmly believe that each should receive religious, moral, and ethical training in keeping with the faith of his father. To that end, we provide a complete program of non-sectarian religious training."[157] In addition to services, this "complete program" included participation in student organizations and regular prayer time. The Jennie Martin Sunday School Class, one of the best-known and longest lasting groups, emerged in 1926 for older girls. Named in honor of a longtime employee of the orphan education program and one of Scotland's first female matrons, the group provided Christian education, support and leadership opportunities.[158] Girls in the Jennie Martin class also taught Sunday school to some of the younger students. The Christian Endeavor Society, founded in the late 1930s under the auspices of the Franklin County Christian Endeavor Union, became another popular student-led group. It met weekly on Sunday evenings for fellowship and discussion and sponsored special services, speakers and events.[159]

While the school did not force students to pray, prayer figured prominently in the lives of many Scotland students. Edie '41 recalled, "I was brought up to say grace, to say my prayers at night, so I think we were given a good education, a moral education."[160] When asked whether he and his classmates

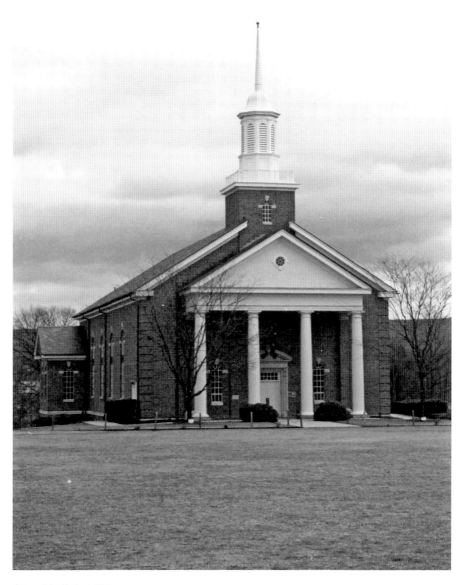
Chapel built in 1970.

prayed at meals or bedtime, Frank '71, speaking thirty-eight years later, said, "Yes. I even remember the prayer. 'For Christ the Lord who came to save us, for all the love and kindness we have known, for these God's gifts to us our father we are thankful. Amen.'"[161] Despite Scotland's public funding and several twentieth-century court cases limiting the role of religion in public schools, Scotland students continued to attend chapel and participate in prayer and religious activities right up until the time the school closed. Most parents supported and encouraged these activities, which took place outside of the regular school day. Jim Lowe '70, who served as a teacher and administrator during Scotland's last few decades, explained that when prospective students—especially those from African American communities with deep religious roots—came to visit Scotland for an admissions interview, their mothers often asked about chapel services and expressed strong support for this aspect of the Scotland experience.[162] In the 1990s, Scotland began hosting an annual Mother's Day chapel service, which became a major event for many students and their mothers.

Scotland Teachers

While former Scotland students express a range of opinions about the education they received at Scotland, on one point, they come close to consensus. At Scotland, they found excellent teachers. Although some former students said they would have appreciated more racial diversity among the faculty (teachers were mostly white) and a few described negative classroom experiences, overall, alumni of multiple generations considered their teachers to be among the school's greatest strengths. In fact, many described how members of the SSVC faculty continue to serve as guides in their adult lives, as they imagine what their former teachers would think of their current decisions and life choices. Harriet, a sophomore when Scotland closed, captured the feeling when she said, "There are so many people you don't want to let down."[163] For their part, the SSVC faculty invested deeply in the school and its students and enjoyed a sustaining camaraderie with one another.

Former SSVC teachers point out that when young teachers came to Scotland, one of two things usually happened. They either left within the first two years or they "stayed for life," meaning they retired as thirty- or thirty-five-year veterans of the school. Because more fell into the latter

group, Scotland maintained a highly stable teaching staff. SSVC teachers had competitive salaries and benefits, but they attributed their school loyalty largely to other factors. When asked what teachers most appreciated about Scotland, John Chontos, veteran social studies teacher and coach, captured the prevailing sentiment. Without hesitation, he responded, "the kids" and "the people we got to work with."[164] Scotland teachers, as part of a small staff at a school with limited resources, knew how to be flexible and work as a team. In addition to teaching their classes, often for multiple grade levels, they took on many other assignments. Don Engle and Dave Frey, hired as English teachers in the mid-1970s, recalled a visit from legendary basketball coach turned principal Marshall Frey during their first week on the job. In a no-nonsense tone, the principal said, "I need one of you to take on the yearbook and one of you to help with the school play. You choose." With that pronouncement, the two new teachers divvied up the work. Engle enjoyed photography, so he took on the yearbook, and Frey reported having at least watched plays so he joined the 1974 effort to produce *Arsenic and Old Lace*.[165] Their experience typifies that shared by many Scotland teachers. Numerous young coaches, for example, found themselves scrambling to learn sports they had never played, guiding teams through long seasons with little pay. Despite the demands on their time, when former teachers talk about "Scotland kids," it is easy to see why they remained so dedicated to the school. They describe their shared experiences with warmth and humor and a strong sense of responsibility and mission.

Cap Heckler relaxing with students, circa 1950s.

In addition to this bond with students, former Scotland teachers built their own strong sense of community. During the period when the children still ate their midday meal in the cottages, faculty shared a relatively long lunch served family-style in the dining hall. This allowed time to relax and recharge in a supportive environment where one could share both genuine concerns about the day and practical jokes and good humor. In addition, teachers, and many administrators, shared time together outside of school whether it be for Friday morning breakfast at the nearby Green Village Diner on Route 11—a ritual that continues to this day for many former teachers—post-graduation gatherings or poker nights at Camp Legion or the annual golf outing to Mount Union on the first day of summer. The particulars of these activities might have changed with the time period, but built-in opportunities to socialize and build relationships combined with teachers' longevity and shared sense of purpose resulted in a strikingly congenial Scotland faculty.

Former SSVC teachers continue to get together. Pictured here at a picnic in 2011.

5
Life Outside the Classroom

A couple years after the Scotland School closed, Gerry Wilson and his wife headed to Philadelphia for an SSVC alumni picnic. Gerry taught physical education and coached several sports at Scotland from 1968 to 2003 but was best known for his success as a boys' basketball coach, having led his teams to four state championships between 1994 and 2003. For Gerry and Rose Wilson, the trip to Philadelphia offered a chance to catch up with former students and reminisce about shared experiences at Scotland. Greeted warmly when they arrived, the Wilsons enjoyed good food, lively storytelling and no shortage of banter about who really was "the best" when it came to Scotland athletes. A few of the men even lined up on the spot to race for bragging rights, despite being quite a few years removed from their days as state gold medalists. And, of course, Gerry's students always wanted to know who among his players would make the all-time starting five on his dream basketball team.[166] Coach Wilson's brief retelling of this day, which was capped off with a festive neighborhood block party, provides a small glimpse into the world of Scotland athletics, one shaped by both intense competitiveness and an enduring sense of family. This world, along with experiences in numerous other extracurricular activities, played a vitally important role in the lives of Scotland students.

On the surface, extracurricular activities at Scotland served the same functions for young people as they did in other schools. They provided fun and stress relief, improved time management, fostered teamwork and uncovered hidden talents. Like their peers, SSVC students sometimes used

sports or music to earn college scholarships or launch future careers, often as teachers or coaches and, more rarely, as professional athletes or musicians. A few notable alumni (e.g., Maurice Heckler, Charlie Lesher, Bill Peck and Jim Lowe) even returned to Scotland and enjoyed illustrious careers as teachers and coaches at their alma mater. Despite these similarities, however, the extracurricular program at Scotland reflected distinctive features of the SSVC experience.

Most importantly, the extracurricular program showed all the ways in which the Scotland School was a small, close-knit and, in many respects, self-contained community. Despite the steady support of veterans' organizations and an active parents' association in the school's later years, Scotland coaches and advisors could never depend on well-funded booster clubs or wealthy families with money to spare for musical instruments or expensive youth sports programs and all the best equipment. As for students, whether they won or lost, performed well or poorly, got injured or received awards, they did not go home at the end of the day—at least not in the usual sense. Whatever they needed had to be found within the school community, a community that in many ways operated on its own without the built-in support of a traditional hometown. To be sure, many local residents loved to see the Scotland band join the parade route, the football team storm the field on a Saturday afternoon or the basketball team take to the hardwood, but Chambersburg had its own teams, as did all the neighboring towns. Without a ready supply of families and neighbors to attend school events, Scotland students relied on their teachers, coaches and other staff members—and often the spouses and families of these individuals—to fill the void. There were teachers who donned their Scotland garb and filled the stands; coaches who remained on campus late at night washing team uniforms in preparation for the next day; and coaches' spouses who regularly made cookies for away games. In short, members of the Scotland family depended on one another in ways one would not find in a typical school.

This close-knit school was also quite small compared to most public school districts. On the positive side, this maximized the involvement of students and staff alike and gave almost everyone a stake in the school's success. Out of necessity, Scotland students usually participated in multiple activities. Even in recent years, when the trend in high school sports was to specialize and play one sport all year, Scotland athletes, including those competing at the highest level, often played three sports. Larry '91 provides an excellent example. In addition to being a strong student and a state champion and school record holder in the 110- and 300-meter hurdles,

LIFE OUTSIDE THE CLASSROOM

Seventh grade football team, circa late 1960s.

Larry excelled in football and basketball, participated in student council and played trumpet in the band.[167] At the same time, students who might not have otherwise joined a team or taken up a musical instrument due to lack of interest or aptitude often did so at Scotland because the small numbers ensured that almost anyone could participate in some fashion. Gerry Wilson still recalls his first day as a junior high football coach when he saw every seventh grade boy, regardless of weight, size or ability, line up for practice. While admiring their eagerness, he knew he had a problem when he noticed some of the boys could actually spin the helmets around on their tiny heads. Those children unable to play safely often joined the team as managers or got involved in other activities. Nicki '91, a three-sport athlete and one-thousand-plus-point scorer on the girls' basketball team, described the benefits of this small community:

> *I don't think the average high school student has the opportunity to be involved in so many activities. Students are encouraged to specialize in one sport or schools are so big that it's difficult to make the team. But having such a small school required that everyone get involved, and I think it made us all more well-rounded, better team players and better leaders.*[168]

Without question, most students left the Scotland community having had opportunities to shine in many different arenas, including sports, music, JROTC and various other groups.

The small size also meant that most coaches, even those known for expertise and success in a particular area, coached more than one sport and likely advised other student organizations as well. As a result, Scotland coaches and advisors achieved an extraordinary level of commitment, longevity and camaraderie. As Nicki '91 explained, "Our coaches were like family and second parents. They helped raise us and taught us values. I learned the importance of humility, perseverance and selflessness from my coaches."[169] Larry '91 put it this way: "Our relationships with each other and with our coaches ran deep. We learned the importance of rigor, discipline and accountability."[170] Many of these coaches stayed for decades. Scotland recognized a select few with permanent markers on campus, including Frey Gymnasium, named in 1991 for longtime basketball coach Marshall R. Frey; Heckler Field, named in 1981 for Maurice "Cap" Heckler who, over the course of more than three decades, coached multiple sports and served as athletic director; and the Roy C. Shields and William C. Peck Memorial, placed at Heckler Field in 1993 to recognize Shields's long career coaching track and field and Peck's significant contributions to football. These four, along with people like Charles E. Mentzer, who directed the music program from 1901 to 1950, represent a much larger group of equally dedicated coaches and advisors who willingly took on many roles to keep the school going and ensure their students' success.

At the same time Scotland's close-knit family promoted widespread involvement and a sense of shared mission, its small size also created challenges in the extracurricular programs. Sometimes there were simply not enough students and staff to cover every sport or activity. For example, in addition to its longest-standing major sports (baseball, football, basketball, track and field and field hockey), Scotland, at various points in its history, fielded teams in boys' tennis, boys' soccer, swimming and diving, wrestling, cross country and girls' volleyball, but given the difficulty in maintaining too many teams at once, these smaller sports tended to come and go. This was especially true for girls, who made up a smaller percentage of Scotland's total population and always fielded a cheerleading squad, as well. When the school added girls' swimming from 1962 to 1972, for example, it replaced basketball, and when volleyball came in 1991, it replaced field hockey. Even with high participation rates, Scotland did not have enough girls to cover both teams at once. The school's excellent music program faced similar

challenges. When at its largest, Scotland offered an impressive array of musical options for its students, but when the population waned, the music department had to eliminate many of those options. In its final years, the school maintained an elementary chorus, a select chorus and a drumline, but efforts to keep even a small marching band met with mixed success.[171] The small size proved challenging for the school theater program, too. Dave Frey, who directed several plays in the late 1970s, explained, "Casting was a problem in that we had to share the same pool of students who were involved with so many other activities."[172] Scripts were often selected with numbers in mind, but even so, for a period from 1979 to the early 2000s, Scotland produced no school-wide plays.[173]

Just as Scotland's small community offered both benefits and challenges for its extracurricular programs, so, too, did it affect how its members interacted with the outside world. On one hand, Scotland's relatively isolated campus offered safety and security to its students, but it also had two other effects. First, up until at least the 1980s, Scotland students had relatively few opportunities to leave campus outside of extracurricular activities. As a result, they valued any chance to board a bus and head to other schools. It broke up the rigid schedule and allowed SSVC students to meet new people and experience different environments. At the same time, the school's relative isolation sometimes led to misunderstandings about Scotland. Some people wrongly characterized Scotland as a reform school for court-adjudicated students, while others, particularly from the 1980s onward, suggested the school recruited top athletes from Philadelphia in order to secure an unfair advantage in sports. Both of these misconceptions riled up Scotland defenders, who quickly pointed out that most students arrived at Scotland as children long before any innate athletic talent would have manifested itself and that no students with criminal records ever attended the school. In addition, SSVC students sometimes confronted prejudices when traveling to other schools either due to orphan stigmas in the early period or racism in later years. While alumni recall many positive interactions with young people outside their own community, they and their former coaches and advisors also remember instances of racial taunting, stereotyping and general crowd hostility that at its worst could include throwing bananas or even chicken wings onto the court or at their bus. In these circumstances, Scotland students stuck together and counted on each other and on their teachers and coaches to help them navigate difficult situations.[174]

All of these community challenges—the limited budgets, small numbers and misconceptions about their school—combined with the individual

struggles Scotland students often had to confront made success, when it came, very sweet. And it did come. While some periods certainly outshone others, Scotland achieved remarkable success in music, sports and a variety of other extracurricular activities over the course of its history. As former students would be the first to say, some of this success can be attributed to the talent and hard work of coaches, directors and advisors. The strict school environment is likely another contributing factor. Several Philadelphia-area alumni, for instance, noted that they could be much more focused at Scotland than they would have been in their home communities. In addition, Scotland's rural location and the requirement that students stay on campus limited what students could do outside of school activities. While no doubt important, none of these factors should detract from the effort, ambition, talent and competitive spirit of Scotland students themselves. They pushed each other. They built pride in themselves and their school. Whether through back-to-back undefeated seasons in the Franklin County Debating League in the 1920s or basketball state championships in the 1990s, Scotland students left a legacy of excellence.

Student Groups

Scotland established its music program as early as 1897, with the formation of boys' and girls' glee clubs, a boys' band to play for all school drill functions, GAR events and local parades and a relatively short-lived girls' band with twenty-nine students by 1902.[175] The fledgling music department added piano and chapel orchestra a few years later. When Charles Mentzer, an accomplished musician himself, arrived in 1901 as music director, he quickly established a high standard of quality, leading various groups to award-winning performances over the next five decades. Scotland became especially well known for its marching band, and in 1905, band members received the honor of traveling to Washington, D.C., to participate in President Theodore Roosevelt's inauguration.[176] The marching band also played in inaugural parades for several Pennsylvania governors, at various military events around the state and in countless parades in nearby towns. Each year on Memorial Day, the band marched to the Scotland Cemetery to remember and honor those who had died, an experience initially intended to show the local community how well Scotland students comported themselves.[177] It is still fondly remembered by many alumni.

Scotland Band in 1937.

After 1950, Mentzer's successors directed many instrumental groups, including, at various times, marching band, concert band, dance band, stage band and a variety of small ensembles. In the 1950s, girls rejoined the band after having been involved only in vocal music, piano and orchestra since the early 1900s.[178] Opening up band to girls made a big difference in the lives of many young women who discovered a passion for band in the ensuing decades. Sally '65, recalling her love for music at Scotland, described how she longed to play alto saxophone but only gained approval to do so when her excellent and demanding band director, Stephen Singel, found her acceptably proficient on the clarinet. With his guidance, she went on to be president of not only the SSVC band but of the Slippery Rock University band as well.[179]

In 1968, Singel established a new group known as the Spanish Fleas, named for a hit song by 1960s instrumental group Herb Alpert and the Tijuana Brass.[180] When Singel retired in 1979, the group temporarily disbanded but was reconstituted in 1982 and directed by Patrick McNamee until 1990. McNamee served as SSVC band director from 1981 to 1996 and, in addition to directing the band, established a popular vocal group patterned after Diana Ross and the Supremes called the Reflections.[181]

The early requirement for all students to take vocal music classes provided a firm foundation for many excellent choral groups. In the late

Scotland School for Veterans' Children

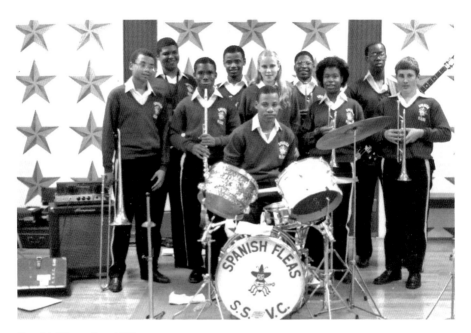

Spanish Fleas, circa 1980s.

1930s and early 1940s, for example, the boys' chorus and octet won the State Forensic League Championships three times. In 1950, the music department added a mixed chorus along with choral groups for sixth graders and junior high students. In addition to these choruses, Scotland students, from the early 1960s to the late 1990s, participated in a variety of quartets, octets, acapella groups and gospel choirs under the tutelage of longtime vocal music director Charles E. Miller. Both instrumental music and vocal music continued at Scotland from the late 1990s to 2009, but budget cuts made it more difficult to maintain the music program at levels seen earlier in the school's history.

As with music, the athletics program at Scotland evolved and expanded for decades, reaching its apex, in terms of win/loss records, in the 1990s and early 2000s. Scotland teams played under two mascots, the Red Devil and the Cadet. School newspapers suggest that the Red Devil came first, but both appeared, often in the very same editions, from the 1930s through the 1950s. After that, the school seemed to settle on the Cadet as its sole mascot. In later years the spelling "Kaydettes" was sometimes used when referring to girls' sports. During its first few decades, Scotland played local teams and other residential schools but eventually joined a county league and began playing a regular high school schedule in the late 1920s. The

Life Outside the Classroom

Scotland chorus with Charles Mentzer, 1930.

school officially joined the Pennsylvania Interscholastic Athletic Association (PIAA) in 1944.[182] Scotland became a charter member of the newly formed Blue Mountain League (BML), which included Franklin and Adams County schools, in 1966 and then joined the Mid-Penn League in 1992 when the BML disbanded. Classification labels changed over time, but Scotland always competed in divisions with small schools of similar size. Scotland teams often played larger schools in non-divisional games. Beginning in 1933, boys who earned varsity letters could join the S Club and gain certain privileges on campus.[183] Eventually, a comparable organization for girls, known simply as the Girls Club, also formed, but members received a club T-shirt rather than a standard varsity jacket.[184]

Although Scotland girls exercised through calisthenics and played informal games such as croquet and tennis for fun, they had no opportunities for competitive sports until they began playing field hockey in the early 1920s. Boys, however, played a limited schedule of football and baseball soon after the school opened. On April 8, 1897, the school newspaper reported on Scotland's first home baseball game held the previous Saturday, offering the following humorous description: "The boys and girls of our institution were as happy over the afternoon's sport as though they had

Scotland School for Veterans' Children

Girls playing field hockey in the oval, circa 1930s.

been sliding down a rainbow with a Star Spangled Banner in one hand and a yard of bologna sausage in the other."[185] Later that same season, the team reportedly defeated the Cumberland Valley Normal School by a score of 22–8.[186] Scotland boys continued to play football and baseball against local teams for the next few decades; they moved to a regular high school schedule in the 1920s.

When Scotland put down a track in 1926, the boys began competing in track and field as well, establishing one of the school's longest and most successful programs. Not only did stand-out coach Roy Shields, who arrived at Scotland in 1941, go twenty-seven years without a losing season, he coached numerous league and district championship teams. In the late 1950s, Scotland achieved recognition at the state level when Milt Dickerson '58, a 440-yard dash specialist, won four individual state titles. In 1991, under veteran head coach Jim Strock, the team made school history by winning Scotland its first-ever Pennsylvania state championship in any sport. During the 1990s, the boys went on to win an astonishing five more state team titles for AA track and field. Between 1925 and 2011, only one team in the entire state won more state titles than Scotland's six (Glen Mills, with seven).[187] Including relays and individual events, SSVC earned thirty-three state titles (twenty-six track, seven field) over the course of its history. Eleven different boys won individual state golds; five won two or more, including hurdler and jumper Braheem Powell '97, who

took home a record five, not counting relays, between 1995 and 1997.

Girls' track and field, while never as competitive at the state level as the boys' program, proved to be the most successful girls' sport at Scotland. Although the team only officially launched in the mid-1970s, it made an immediate name for itself through superb performances by several young sprinters, including Ramona Lattany '79, the only SSVC girl to still hold a district record (for the 440-yard dash). Including relays and individual events, SSVC earned twenty-three district titles (twenty track, three field) over the course of its history. Eleven different girls won district AA championships in individual track or field events, and relay teams captured five more golds. Three Scotland sprinters/hurdlers won two or more individual championships.

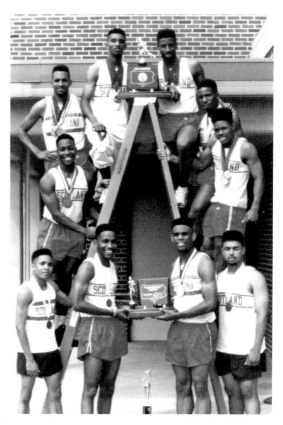

Members of the 1991 PIAA state championship track team.

The same year (1926) Scotland put down the track, it also built its first gymnasium, allowing boys and girls to begin playing competitive basketball. With the exception of a short hiatus for the girls' team from 1962 to 1972, when they took up swimming and diving instead, both teams continued to play until 2009. The girls' team saw stand-out performances from individual girls over the years, including two who scored more than 1,000 points. They enjoyed many winning seasons but, overall, achieved mixed results with respect to wins and losses. From the start, the boys' basketball program proved highly competitive. In addition to winning at the county and district levels, the team made it to the state playoffs on numerous occasions in the

Members of the girls' track team with coach Dot Doyle, 2003.

1940s, '50s and' 60s during Marshall Frey's twenty-two-year tenure. The Cadets continued to put together winning seasons under head coach Ralph Dusman, winning their first Blue Mountain League title in 1983. By the late 1980s, Coach Wilson, who took the helm in 1985, believed his team could compete for the Pennsylvania single-A state title, and after two near misses in the early 1990s, Scotland finally brought home gold in 1994 and repeated in 1995. The boys remained competitive at the district and state level and won back-to-back state championships again in 2002 and 2003. Eleven boys scored more than 1,000 points at Scotland, with 2002 graduate Charles Davis scoring a school-record 2,018. As with track and field, many SSVC players went on to compete in college.

The football team played from 1898 to 2009, making it Scotland's longest-running athletic program. The school's small size, especially during periods of low enrollment, strained efforts to field a sufficiently deep football team, but Scotland proved consistently competitive and often successful. A strikingly large number of male teachers served on the football coaching staff at various points in their careers, but it was under veteran head coach Ken Katusin, guidance counselor and former social studies teacher, that SSVC won its Pennsylvania state class-A championship in 1992. Playing in Altoona on a "bitter cold day" in the wake of a twenty-seven-inch snowfall,

Life Outside the Classroom

Right: Basketball players Jim Brown '42 and Margaret "Terry" Miller '42.

Below: Girls' basketball team, circa 1991.

The 1994 PIAA state championship basketball team.

the team defeated Smethport 24–7. In addition to plenty of celebrating back on Scotland's campus, the boys traveled to Harrisburg for a gathering and photograph with Governor Robert P. Casey and state senator Terry Punt. As a particularly versatile group of athletes, several members of this team also competed on the 1991 and 1992 state-winning track teams and the 1994 state-winning basketball team. John Thornton, '94, a stand-out in both football and basketball, went on to play football at West Virginia University and professionally for the Tennessee Titans and Cincinnati Bengals. Scotland retired his high school jersey in 2004.

Outside of music, sports and military-related organizations, the most active clubs at Scotland centered on art, drama, student government and literary endeavors (e.g., Curtin Literary Society, newspaper and yearbook). Pictures of the art club began appearing in yearbooks in the 1950s and continued to appear in almost every yearbook through 2009. Open to any student interested in art, this club, among other projects, made decorations for school events and dances.[188] Early photographs suggest Scotland students began performing plays soon after the school opened. With some variation, Scotland, through the 1970s, typically produced one major play or musical each year, with students building the sets and altering the costumes as well as performing. In the mid-2000s, musicals

Scotland football players, circa 1940s.

The 1992 PIAA state championship football team.

Students performing in a production of *Books and Crooks*, 1973.

returned to Scotland under the direction of Joyce Gerstenlauer. After years of debating its merits, Scotland established its first student council in 1933, when Superintendent Smathers agreed to a "trial run."[189] This leadership group continued to operate until 2009.

The school newspaper proved to be one of Scotland's earliest and most impressive student endeavors. Those working in the print shop began issuing a bimonthly school newspaper, the *Industrial School News*, on February 2, 1896. The newspaper, renamed the *Scotland Courier* in the 1920s, included exchanges with many prominent newspapers and magazines around the country, including the *New York Times* and *Baltimore Sun*, as well as local papers in the Chambersburg and Harrisburg areas.[190] In the mid-1930s, the paper switched to a monthly publication, and in 1938, it stopped publishing in the summer months but remained a vital part of the school. The Curtin Literary Society, established on March 16, 1906, held programs of a literary nature, including plays, throughout the year and remained in existence for several decades at Scotland. Its express purpose was to "foster higher morale and intellectual standards, increase the knowledge and general culture and teach a reverence for the name Andrew Curtin among pupils of the school."[191] In addition to the Curtin Literary Society, Scotland became a charter member

Life Outside the Classroom

of the Franklin County Debating League in 1924 and had back-to-back undefeated seasons. Eventually, every school in Franklin County became part of this league. Scotland competed at least through the 1930s.[192] In 1937, Scotland published its first yearbook, featuring twenty-one seniors. Initially named *Reveille to Taps*, its title soon changed to *Taps*, symbolizing the close of one's school days just as "Taps" played to close every day at Scotland.

Time for Fun

At the same time that structured and competitive extracurricular activities played an important role in students' lives, Scotland provided opportunities for informal sports, recreational activities and social time. As early as the 1910s, for example, staff organized an "industrials" baseball league wherein the boys of various shops competed against each other for fun.[193] The 1928–29 school bulletin listed the following intramural activities: tennis, marbles, skating and swimming, along with two basketball leagues. In the 1930s, staff instituted an intramural volleyball league for girls and a new marbles tournament for boys under the age of fifteen. The winner of Scotland's tournament competed in the Franklin County District Marble Championship.[194] Scotland students of several generations loved marbles and jacks and spent many hours engaged in both games. Sally '65 recalled jacks as her very first extracurricular activity at Scotland and described how kids would draw the marble circle in a dirt patch alongside the playground for friendly competitions.[195] Scotland also hosted an annual field day, or what later became known as Superstars Day, through much of its history. In the early 1980s, with the help of SSVC alumni such as Jim Lowery '77, Bob Krieger '75, Terry Grove '79 and Curtis Boos '80, the school introduced an active and successful youth football program. Around the same time, Jim Lowe '70 launched youth basketball for boys and girls.[196] Under the auspices of the Chambersburg Recreation Program, fourth and fifth graders played basketball every Saturday morning against other teams. Lowe also took them to a few local tournaments each year. These programs remained in place until the school's closing.

In addition to intramurals, young children played outside after school, and students of all ages relaxed and socialized during designated periods on weekends. Scotland's beautiful campus fostered many outdoor activities in a fresh-air environment. One enduring ritual, the annual fall

Scotland School for Veterans' Children

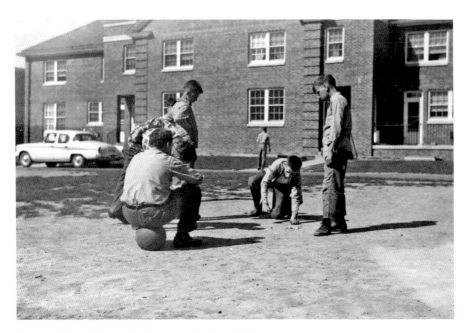

A game of marbles on the playground, circa 1955.

rabbit hunt, really got the boys moving. The tradition began in the early 1900s and continued into the 1950s. The youngsters, usually working together to encircle each rabbit, would close in until one boy could make a move. A *Courier* reporter in 1933 offered this description: "After a flying tackle into the cinders, Ed Barr came up with brother rabbit in his hands, and the usual procedure, that of twisting the rabbit's head off, was immediately done."[197] On that particular day, the hunt yielded twenty-three rabbits for dinner. Other outdoor events for younger children, such as the long-standing Easter egg hunt and the VFW-sponsored fish rodeo, especially popular in the 1970s and 1980s, gave the children fun activities to anticipate and enjoy.

In 1985, responding to interest from some of the boys, SSVC worked with the commander at nearby Letterkenny Army Depot to have local Boy Scout Troop 247 move its meetings to the basement of SSVC's Chapel so that Scotland boys could participate. According to Diane Bowen, who served as the troop's first female Scoutmaster after the Boy Scouts of America opened the position to women in 1988, the troop grew fast and sometimes included forty to sixty boys.[198] Four Scotland boys eventually achieved the rank of Eagle Scout. Although not open to girls, Scouting provided SSVC boys with another opportunity for outdoor play and learning.

Life Outside the Classroom

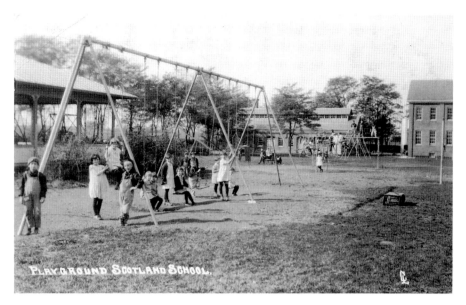

Children on the playground, circa early 1930s.

A rainy day fish rodeo sponsored by the VFW, circa 1980s.

Children leaving the movie theater, circa 1954.

Veterans' organizations provided the school with a number of gifts for indoor entertainment as well. In the 1920s and 1930s, these included a Victrola/radio combination and movie projection equipment, which allowed children to enjoy weekly movies. Typically, after Saturday morning chores, younger children stocked up on candy at the canteen and then went to the movie, while the older kids socialized at the canteen and listened to the free jukebox, also provided by a veterans' group. In the evening, the older students attended a movie.[199] The canteen, located in a recreation space converted from the former girls' dormitory (after the girls moved to the cottages), operated until the late 1960s and provided an informal space for students to gather and make purchases of candy, soda and other small items.[200] Each student was given an account, with money coming from friends, relatives or veterans' groups. To avoid carrying cash, students for many years used a "money book" with "script-type money" printed in the print shop.[201]

In 1953, indoor leisure changed considerably when television came to Scotland. According to the 1953 yearbook, which incorporated a TV theme, students "spent many happy and worthwhile hours viewing the modern miracle." Eventually, watching Sunday afternoon football and other sporting events as time allowed became especially popular. In later years, the school

granted students permission to have small televisions in their rooms to play video games.[202] Students also looked forward to the dances and parties held at various times throughout the year. Dances, including formal ones such as homecomings, proms and military balls, provided one of the few sanctioned opportunities for dating. Although always strict about how students of the opposite sex spent time together—for many years, for example, partners were expected to keep two feet between them while dancing together—some dating opportunities existed even in the early period. Several alumni from the 1950s and 1960s described how on Sunday afternoons they could talk while walking hand in hand on the oval. In later years, the administration introduced informal socials, eased rules a bit at dances and gave students more freedom to spend time together in typical teenage fashion. As is the case with all teenagers, Scotland students found creative ways to maximize their social and romantic time together, and quite a few long-term relationships developed at the school. Some students went on to marry—many soon after graduation and some after the loss of their first spouses.

6
Fight for Survival

When Frank Frame, longtime teacher and administrator at SSVC, decided to take Professor Rod Tolbert's graduate course in public relations at Shippensburg University in the summer of 1990, he had no way of knowing that within a few months, he would be acting superintendent of SSVC and using every public relations tool available to him in a battle for Scotland's very existence. In February 1991, Governor Robert P. Casey proposed a budget that if enacted would have forced Scotland to close just four years shy of its centennial. While SSVC ultimately prevailed in this battle and remained open, the threat of closure did not dissipate quickly, and school leaders in the ensuing years made important decisions with this concern in mind. In the immediate aftermath of the 1991 fight, Frame introduced curriculum changes, cut staff and worked closely with admissions director Jerry Stewart in an attempt to diversify and expand enrollment. In a proactive initiative in 1996, Frame led an effort to create the Foundation for the Scotland School, a 501(c)(3) nonprofit organization, to bolster the school's economic resources, making it less vulnerable to potential state spending cuts. Between 1996 and 2009, when SSVC closed, the foundation executed two major capital campaigns and carried out numerous fundraising projects on behalf of the school. During this same period, four men served in the position of superintendent. Howard Bachman took office in 1999 when Frame retired and served until 2004. After a short stint by Carmi Wells, Ronald Grandel assumed the position in 2005 and served until the school closed.

The Crisis of 1991

Over the years, Scotland frequently struggled to secure adequate state funding, but the first serious attempt to close the school occurred in 1991. The crisis began six weeks after Frank Frame became acting superintendent in December 1990, following Francis Calverase's resignation. Officially appointed superintendent a year later, Frame served until 1999, when he became president of the Scotland School Foundation. His straightforward demeanor, steely determination and great love for SSVC served him well in his role as school defender. Governor Casey's budget, announced on February 6, 1991, increased overall funding for basic education but cut Scotland funding to a level that indicated his intent to close the school. Superintendent Frame, who had been told about the budget by an official from the Pennsylvania Department of Education a few days prior to its release, acted quickly. He got off a letter to parents dated February 5 letting them know what was coming and urging them to lobby state lawmakers who would ultimately have to approve the budget. Two days later, he called his faculty and staff together for a two-hour informational meeting with state senator Terry Punt, who represented Franklin County and pledged to support the school in the legislature. Most importantly, Frame began developing the school's three-pronged response strategy: 1) responding to the state's concerns by offering new proposals for the school; 2) gathering extensive data in an effort to show Scotland as essential and effective; and 3) winning the public relations battle. Superintendent Frame coordinated the school's response and handled the press, but a large number of Scotland supporters, including faculty, staff, students, parents, alumni, veterans' groups, unions and local community members, joined the effort. Within days of the budget's publication, both sides had established their positions.

On Casey's order, the state's case fell largely to the Pennsylvania Department of Education (PDE) under the direction of Secretary of Education Donald Carroll. He and Commissioner of Basic Education Joseph Bard, to whom the school directly reported, took on the delicate task of providing a clear rationale for closing Scotland without offending veterans and their many advocates within the state legislature. U.S. involvement in combat operations in the Persian Gulf at the time made Carroll and Bard's job all the more difficult. Pennsylvanians supported veterans and their families at a high level during Operation Desert Storm, and neither the administration nor legislators wanted to appear unpatriotic or unsympathetic to veterans. With this in mind, PDE endeavored to recognize and praise Scotland's long and

noble history in the state while simultaneously arguing that the school no longer lived up to its original mission and had become too expensive. State officials also claimed veterans and their children could have their needs met through existing public schools and other support agencies.

Under Secretary Carroll's direction, PDE summarized the Casey administration's rationale for closing Scotland in a document distributed to legislators titled "Information Pertaining to Scotland School for Veterans' Children."[203] The document explained Scotland's original mission as a statewide institution for housing and educating children orphaned or destitute as a result of their parents' military service. By 1991, according to PDE, few, if any, orphans remained at Scotland. In addition, PDE noted that with 73 percent of SSVC students coming from Philadelphia, the school no longer represented the whole state. The document questioned state support of an institution for non-orphans who could receive support services through local schools and communities and noted that many similar institutions around the country had been closed. In the document, PDE further claimed that a majority of students at the school (287 out of 354) did not meet any of the school's admissions criteria except veteran affiliation. The authors of the document wanted legislators to know that the school no longer served destitute orphans from around the state of Pennsylvania.

In a much-maligned editorial for the *Sunday Patriot News* published on March 17, Commissioner Joseph Bard reiterated the Casey administration's primary argument for closing Scotland with a headline reading, "Scotland School Education Cost Higher Than That at Harvard." While few editorials rankled Scotland supporters as much as this one—SSVC Alumni Association treasurer Robert Shrawder '57, for example, had a scathing response published the very next day—the provocative headline reflected the state's main argument that Scotland's cost to taxpayers could no longer be justified. "Information Pertaining to Scotland School for Veterans' Children" pointed out that the state paid $27,147 per pupil at Scotland in 1990–91, an increase of more than $15,000 per pupil since 1980–81, despite decreasing enrollment in the 1980s. State officials also noted that the school had submitted a document the previous October projecting an additional $20 million required for capital projects and infrastructure needs at the school. If approved, this would push per-pupil spending to $33,000 per year. In the same section of the report, PDE pointed out how inefficiencies at the school, most notably personnel costs for teachers and staff in under-enrolled programs, further strained the budget. By 1991, only nineteen students attended first and second grades combined, and many of the trade courses

had only a few students. From the perspective of the Casey administration, the $8.6 million per year being spent on Scotland could be better used in other educational programs for the commonwealth's children.

Throughout the spring of 1991, Scotland's leadership responded to state criticisms in several ways, but Superintendent Frame prioritized getting a concise rebuttal document into the hands of legislators and other interested parties as quickly as possible. This document, dated March 10 and titled, "Information Pertaining to Scotland School for Veterans' Children: A Rebuttal to the Pennsylvania Department of Education," responded directly to each of the state's arguments, including those regarding the school's mission and student population.[204] While granting that a large percentage of SSVC students came from Philadelphia, school leaders pointed out that twenty-eight Pennsylvania counties still sent students to Scotland in 1991 and the school had a plan in place to expand enrollment further. They also noted that Philadelphia had more Vietnam vets than any other county in the state. The rebuttal came out strongly against the charge that students attending SSVC no longer met admissions requirements. According to school officials, as of March, 10, 1991, 262 Scotland students out of 356 had parents who served in combat. While the school provided a home to only one orphan and twenty-seven children with only one living parent in 1991, administrators identified 90 percent of students "at risk" and 100 percent fully eligible for admission under the law.[205] According to Frame, state representatives came to Scotland and reviewed student files to verify this fact and, ultimately, issued an explanatory memo and revised version of their own document correcting the misperception extended in the original one.[206]

In their rebuttal document, school leaders also addressed the question of cost. Although they believed PDE overstated SSVC's per pupil spending, they did not dispute that costs had been rising. According to the document, this could be attributed primarily to increases in personnel costs, which by 1991 consumed 75 percent of the school's budget, as well as to a failure on the part of the state to keep up with infrastructure needs over the years. They explained how new child labor laws in the 1960s limited the amount of work at the school that could be done by the children. As a result, Scotland hired more adults to carry out tasks previously handled by students. During the same period, unions and collective bargaining agreements began to play a greater role in Pennsylvania labor relations. Scotland employees belonged to local chapters of both the Pennsylvania State Education Association (PSEA), the state teachers' union, and the American Federation of State, County and Municipal Employees (AFSCME). By 1991, these groups had been

bargaining for higher wages for decades. The SSVC administration argued that despite these rising costs, Scotland's per-pupil spending remained lower than comparable residential schools. Additionally, they contended that the projected $20 million needed for capital improvements could potentially be reduced to $10 million.

As previously noted, the Scotland community's response to the governor's closure threat extended well beyond this initial rebuttal. First, Frank Frame and his team offered plans to address legitimate cost concerns. In fact, following a budget meeting with Scotland's board of directors in January, Frame had been exploring cost-saving measures *before* the governor announced his budget. Tentative plans called for phasing out the primary grades at Scotland, scaling back and eliminating some of the trade programs offered by the school and cutting projected costs for capital improvements from $20 million to $10 million by deferring some projects and turning over others, most notably asbestos mitigation, to school staff. Upon finding out that Scotland's funding might be cut altogether, Frame, wanting to be proactive and to show a willingness to make difficult choices, put together a barebones budget that cut expenses by $2 million. Almost $1.7 million in cuts were projected to come from reducing personnel. In addition to cutting teaching positions based on the curriculum changes, this austere budget called for other steep reductions in administrators and staff. To find an additional $300,000, Frame reluctantly eliminated the extracurricular program from the budget. The superintendent, of course, hoped that such an extreme budget would never be necessary, but if his choices turned out to be closing the school or accepting a significant budget reduction, he wanted to be prepared. In addition to tackling the budget, Frame worked with admissions director Jerry Stewart to develop a plan for expanding student enrollment at Scotland and began to implement it in the spring of 1991 rather than wait to see if the school would remain open. Frame signaled legislators that he had every intention of addressing the state's concerns and moving the school forward accordingly.

Although responsive to constructive criticism, school leaders never wavered in their belief in Scotland as an important and highly successful institution well worth the money needed to operate. The administration used data to show how SSVC students, while rarely orphans in the traditional sense, remained vulnerable to an increasing number of societal problems, including poverty, addiction and violence. School leaders prepared a slideshow, later presented by Franklin Fisher, commander of Veterans of Foreign Wars of Pennsylvania, to lawmakers on the House Appropriations

Committee. The slides provided background information on students from the class of 1990 and their families.[207] By showing how SSVC students had been forced to confront everything from child abuse and drug addiction to gun violence, school leaders hoped to demonstrate how important it was to continue funding Scotland School, a place where students could be kept safe in a "total-care community" and thrive as students and developing citizens. Like their predecessors many generations before, school leaders in 1991 made the case that allowing children to live and learn at Scotland was not only the right thing to do but also the financially prudent one because students who attended Scotland would be more likely to become healthy and productive members of society.

To further augment the case, admissions director Jerry Stewart compiled information on the compositions of SSVC families, including data on percentages of single parents, divorced parents, incarcerated parents and parents with disabilities. Scotland put forth a straightforward argument. SSVC students might not be orphans, but they had plenty of challenges and would be better off attending Scotland than remaining in their home communities. Longtime guidance counselor Ken Katusin provided extensive documentation on the most recent graduating classes in order to show the high percentage of alumni attending four-year colleges, serving in the military and receiving technical training. In addition, on at least one occasion in early May, Frame sent SSVC student TELLS test scores to a legislative subcommittee in order to show a favorable comparison with Philadelphia schools. He included an editorial from the *Philadelphia Inquirer* dated May 4, 1991, discussing the dismal state of Philadelphia schools.[208]

All the while school officials gathered data and floated budget proposals, they continued to lobby legislators and encouraged other school stakeholders to do the same. The school hosted a visit from members of the House Appropriations Committee on March 11, 1991, during which students, teachers, alumni, veterans and union representatives from PSEA and AFSCME expressed opposition to the closing. Several weeks later, six members of the Senate Military and Veterans' Affairs Committee visited the school and talked with students and staff. On April 1, students, parents and supporters attended a rally at the capital, and on April 30, several SSVC representatives testified before the House Subcommittee on Education explaining not only the negative effect on students of closing the school but also what it would do to the local economy and how it would hurt employees, especially in households with two parents employed by the school. Among those who testified was SSVC senior Tara Nicole Smith, a young woman

who later went on to a distinguished military career, crediting Scotland for much of her success.

Teachers, many of whom had been at Scotland for decades and had often served as coaches and advisors, extoled Scotland's strengths and expressed concern for the future of their students. School supporters, including many young students, wrote letters to legislators and to the local press describing how SSVC changed their own lives or the lives of people they knew. Distinguished alumni, including a West Point graduate and a college dean, gave public support to the school as did local business leaders and the mayor of Chambersburg. Supporters wrote letters to everyone from President George H.W. Bush and Colin Powell to Oprah Winfrey in an effort to raise awareness.[209] On May 23, 1991, Frame and Donnmaria Tucker-Killinger, a representative from the SSVC Parents' Association, appeared on the cable show *Under the Dome* to discuss the school. On April 1, students, parents and supporters attended a rally at the capitol in Harrisburg.

Numerous veterans, both as individuals and as representatives of their groups, wrote letters of support for the school. On May 15, 1991, veterans, organized in part by Edward Hoak, Pennsylvania's American Legion state adjutant, held a rally in front of the state capitol to protest the governor's budget. According to a press release put out by the Pennsylvania War Veterans Council, "A large yellow and white banner of petitions filled with tens of thousands of names of SSVC supporters wrapped around the organization area."[210] To further emphasize veteran support, the school made available to lawmakers a document showing that between 1988 and 1990 alone, Pennsylvania veterans' organizations contributed more than $65,000 to the school, not including money contributed for special activities or for individual students.[211]

Scotland's survival in 1991 could be attributed, in no small measure, to this high level of support and activism on so many fronts. In the end, with backing from local lawmakers as well as representatives from Philadelphia, in both political parties, the legislature appropriated $7,637,000 to SSVC for 1991–92. While this marked a decrease from the previous year of almost $900,000, it was a far cry from the potential $2 million cut Frank Frame had been contemplating when he put together his barebones budget. Frame credits Representative Jeffrey Coy of the Eighty-Ninth District and state senator Dwight Evans of Philadelphia with devising a plan to supplement state funding and limit the total cut.[212] Evans's approach, which ultimately won approval, allowed a portion of the per-pupil funding students received in their home school districts to be transferred to Scotland, a practice known

as portability. This plan added just over $1 million to Scotland's budget. By carrying out his tentative proposals to cut costs through scaling back the trades and eliminating the primary grades, Frame could get Scotland through the year without having to cut vital extracurricular activities or other major programs. The question of funding for capital projects remained unresolved for the time being.

The near closing had taken a toll on the school community in the spring and summer months, with uncertainty about the future causing a high level of anxiety among staff, students and parents, all of whom had to make decisions without knowing whether or not Scotland would reopen in the fall. In fact, when Dr. Benjamin Carson delivered the 1991 commencement address and the rest of the students and staff left Scotland at the close of the academic year, the fate of the school remained unknown. It is not surprising then that their return to campus on August 30, 1991, for a school-wide picnic to kick off a new year at Scotland brought a sense of relief and hope.[213] On Parents' Day that fall, the school held a ceremony to honor some of the individuals who had worked hard to save the school, including state senator Terry Punt, state representative Jeffrey Coy and several members of the Parents' Association. Clearly, in the fall of 1991, the Scotland community felt that the school had only narrowly escaped closing and that future threats of closing had not been eliminated. Despite these concerns, many aspects of day-to-day life at the school remained unchanged. As the academic year began with the usual daily schedule, students geared up for fall sports, JROTC and various clubs. To a casual observer, the stress of the previous nine months and the new realities brought about by a tightened budget might not have been immediately apparent.

Despite the air of normalcy, Scotland changed that fall. With the decision to phase out the school's primary grades, Scotland, for the first time since 1912 when Chester Springs closed, would no longer have a first grade class. When the five remaining second graders moved up the following year, the primary program would no longer exist. Even more fundamentally, SSVC's long history as an industrial school came to an end. Well before the 1991 budget cuts, it had become increasingly difficult to maintain the trades at Scotland due to decreasing enrollments and a rising number of students choosing the college prep program. Advances in technology, especially the advent of computer usage in the 1980s, also made it more difficult to keep the industrial program equipped with the most up-to-date resources. With the significant budget cut in 1991, Scotland eliminated the following programs: health occupations, electric, carpentry, barbering, driver education and

Fight for Survival

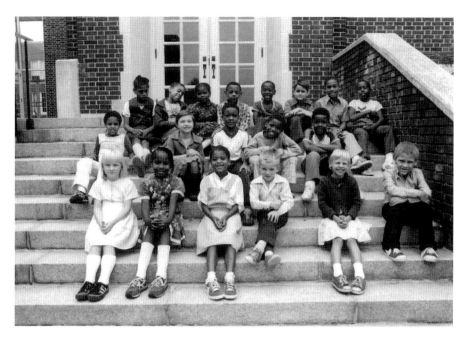

Students in the primary grades, circa 1980s.

printing. The school removed $1,848,000 from the capital improvements budget that had been slated for renovating the industrial building.[214] A portion of the savings from these programs was funneled into business education, industrial arts technology, cosmetology, home economics and bake shop in order to modernize them technologically. Five years later, the bake shop was reorganized as a more broadly defined culinary arts program. The administration also entered into discussions with the Franklin County Vocational Technical School to see if SSVC students might be able to attend there, but that option never materialized.

In addition to making these program changes, Scotland's leaders moved forward on their assurances to the state that they would implement a strategy for expanding SSVC enrollment beyond Philadelphia. It had never been easy to recruit in certain areas of the state, especially western Pennsylvania. In addition, more recent veterans, especially from Vietnam, did not join veterans' organizations at the same rates as their predecessors, making it more difficult to recruit through word of mouth. Despite these challenges, the SSVC administration knew it needed to respond to the state's criticism regarding enrollment. Beginning as early as March 1991, Frame and admissions director Jerry Stewart developed a plan to target counties

across the state. They started with counties contiguous to Franklin County (Fulton, Huntingdon, Mifflin and Juniata) and moved out in concentric circles from there. Frame and Stewart also sought to increase student and parent satisfaction at Scotland in an effort to make the school as attractive as possible to perspective families.

A new school brochure, prepared in advance of the 1995 centennial celebration, featured quotes from students and parents expressing their heartfelt support for the school. To further enhance student satisfaction, the school established honor suites during the 1996–97 academic year for students with excellent conduct and academic records. An area over the dining hall was renovated for the creation of the Dr. Benjamin Carson Honor Suite for boys, and Cottage 34 was established as an honor suite for girls. One of the more innovative approaches came several years later in 2005 when the school organized the Red Blazer Club, a group of impressive students who served as ambassadors and tour guides for the school. Despite these and similar efforts, Scotland never significantly expanded its reach beyond Philadelphia between 1991 and 2009.

In addition to dealing with enrollment challenges, administrators during the 1990s faced ongoing budget difficulties. The restoration of SSVC funding in the 1991 state budget along with additional funds coming from the students' local districts averted the immediate crisis. A couple of years later, under Governor Tom Ridge, the state allocated funds for the construction of a new dining hall at Scotland. Despite these positive developments, Superintendent Frame recognized the importance of finding additional revenue sources for the school, especially in light of the aging campus's ongoing infrastructure needs. In 1996, Scotland supporters, urged on by Frame, established the Foundation for Scotland School, a 501(c)(3) nonprofit organization, to raise money for the school. In February 1997, the foundation's board of directors elected Lloyd Trinklein its first chief operating officer and began making long-term plans for fundraising. In the short run, the group sought to raise money to finish equipping the newly constructed dining hall. The building, named for David S. Boozer, SSVC's longtime dietician, also included a culinary arts center named for General Colin Powell, who made a contribution to the school. Frame secured some additional funding from the state for equipment but not enough to launch the new culinary arts program. Filling that gap became the foundation's first goal, but it extended its efforts well beyond that.

After several years of fundraising, the foundation launched a major capital campaign in 2003 with a goal of $2.1 million. By the time of the campaign,

which focused mainly on the Student Quality of Life Endowment Fund, closed in 2005, it had brought in $1,059,289.95 along with an additional 6 percent above that amount provided in kind. The foundation also conducted an annual campaign supported by regular donations and by several fundraising initiatives throughout the year. An annual golf tournament held at the neighboring Chambersburg Country Club was especially popular. It was named after John E. McAllister, an SSVC Board of Trustees member who helped plan the first tournament but died before seeing the fruits of his labor. An event known as the Tree of Lights, held near Christmas each year, featured students performing musical selections in the chapel and leading carols. Lights, strung up in the shape of a Christmas tree around the flagpole, and a thousand luminaries purchased by donors to honor loved ones could be enjoyed by people driving through the school.[215] Beginning in August 2005, the foundation also began publishing the *Scotland Sentinel*, a newsletter designed to garner further support for the school. While SSVC used money donated by the foundation for a wide range of purposes during this period, the school still relied on state funding to support its core budget. In the turbulent economic climate of the late 2000s, this basic fact proved to be its undoing.

The 2009 Closing

In the aftermath of the great recession that began in December 2007, governors across the United States looked for ways to reduce budgets. Pennsylvania governor Edward G. Rendell proved to be no exception. For the 2008–09 academic year, the state contributed $10.5 million to Scotland's $13.5 million overall budget. The rest came from federal funding and payments from the students' local districts. According to documentation prepared by the state, the school at this time spent approximately $45,000 per student annually, compared to the state average of $11,000 per student. On February 2, 2009, two days before the governor presented his budget for fiscal year 2010, school leaders at SSVC received word from Jessica Wright, the adjutant general at the Department of Military and Veterans Affairs (DMVA), of the governor's plan to eliminate funding for Scotland. As it had in 1991, this decision led to a sharp battle between the state and Scotland's supporters. Once again, the state argued that Scotland cost tax payers too much money, especially in the midst of the worst financial crisis since the

Great Depression, and that SSVC students could do just as well in other, less expensive, schools. On the day Governor Rendell announced his budget, Frank Frame, still serving with the Scotland Foundation, penned a letter to the *Public Opinion*, leading off a flurry of protests, letter campaigns, rallies and testimonials in an effort to once again save the school. On February 11, the foundation hired a lobbying firm, Triad Strategies, out of Harrisburg, to help support their case with state legislators.

Meanwhile, anticipating opposition from Scotland families, the PDE hosted a meeting in Philadelphia on February 7 to address concerns about the closing and to discuss school options for the coming year. Frustrated and angry, parents held their own meeting afterward with alumni and teachers to discuss strategies for keeping the school open. At a meeting hosted the following week by PDE and DMVA officials at Scotland, parents arrived wearing red-and-white "Save Our School" T-shirts and offered a number of emotional protests.[216] At the home basketball game that evening, they held a "Save Our School" rally. The following Saturday, February 21, the Philadelphia School District held an information session for parents. In a letter dated February 18, Scotland superintendent Ronald Grandel informed parents that Philadelphia included sixty-three charter schools in addition to the traditional public schools and that parents should be prepared to provide their children's PSSA scores and recent grades in case they wanted to complete an early registration process.[217]

The question of where SSVC students and employees would go if the school closed remained at the center of the debate for months. According to the Rendell administration, students could enroll in their local schools, including many top charter and magnet schools for those from Philadelphia, or could transfer to the Milton Hershey School, a residential school approximately sixty miles from Scotland that also served students considered disadvantaged in some way. In an April 23 press release, Secretary of Education Gerald Zahorchak claimed that the transition for Scotland students was progressing smoothly, half of the students were already enrolled in new schools for the fall and Milton Hershey had hosted two information meetings for Scotland families. This characterization, which showed up in several press outlets on April 24, outraged Scotland parents. In their view, they only enrolled their children in Philadelphia schools under duress. Even as they fought to keep Scotland open, they knew that waiting to see if the state would change course could result in their children losing any hope of getting into the best public schools. As it was, there was no guarantee that they could secure spots in the top charter schools

in Philadelphia, and Milton Hershey was making no special provisions for Scotland students. In an April 26 *Public Opinion* article, Frank Frame refers to the state's portrayal of options for SSVC students as "a blatant attempt to fool legislators and the public." He went on to say that as of that point, at least a dozen Scotland students had applied to Milton Hershey, and all had been turned down for various reasons, including age and income level. Pam Prophet, an active parent in the SSVC fight, was also quoted in the article saying that "parents are livid" about the state's characterization.[218]

In addition to concerns about what would happen to Scotland children should the school close, supporters also worried about the effect on SSVC teachers and staff. The state suggested that it would help teachers find new positions, but Jean Vargas, the president of the SSVC teachers' association, called this promise into question, as did many individual teachers. In a May 18 letter to the *Public Opinion*, athletic director Gail Schuyler described a May 11 meeting attended by thirty-four Scotland teachers and hosted by the Pennsylvania Bureau of Labor Relations, during which state official Bob Carvella explained options teachers could pursue in other state agencies. If teachers chose not to relocate, however, only the Pennsylvania Department of Corrections had vacancies at the time. Schuyler wrote, "We the teachers of SSVC are qualified in the state system to teach incarcerated adult learners the basic skills to get their GED."[219] Carvella told teachers they could take the civil service exam in order to be eligible for additional jobs, but according to Schuyler, the exam was given only during school hours. Eventually, the state put in place a provision requiring school districts in the mid-state area to give preference to Scotland teachers for job openings for which they were qualified. Throughout the spring and early summer, Scotland teachers did not know whether the school could be saved. If so, they wanted to stay, but if it closed and they had passed up other job opportunities, they would be putting their own families in financial jeopardy. By the second week of June, when SSVC teachers received their official furlough letters, four teachers had accepted positions in other schools.[220]

During this same period, the local business community spoke out in favor of keeping the school open. Back in March, Triad Strategies funded a study of the economic impact of closing Scotland. The study, which the DMVA criticized in a rebuttal as too one-sided, painted a grim picture of what would happen to employment opportunities, property values, retail sales and the value of the SSVC property itself, if the school closed.[221] Then on May 5, the Franklin County Area Development Council (FCADC) sent a letter to state senator Richard Alloway asking him to support the school on

economic grounds.[222] This group argued that it made no sense to close a community asset like Scotland in the midst of an economic downturn. In addition to lost jobs, business leaders worried about the effect of having a large vacant property in the heart of the community. Additionally, if the state did not pay to maintain the property, it would be less attractive to potential buyers and less valuable by the time it was finally sold. In addition to paying maintenance costs for an unused property, the state would also need to fund unemployment benefits to many former employees looking for work.

The period from early May to mid-July 2009 proved to be a confusing time for the Scotland community. On one hand, the Rendell administration, including officials within PDE and the DMVA, operated under the assumption that the school would close. At the same time, Triad continued to lobby state lawmakers, and Scotland supporters carried on with letter-writing campaigns and rallies in the hope of reinstating funding for Scotland in the state budget. Compared with 1991, however, support for the school among local lawmakers and veterans' organizations proved to be less consistent and robust. Led by Adjutant General Jessica Wright, the DMVA, which had been overseeing school operations since 1996, expressed sadness in its official statements about the school closing but seemed to accept the governor's decision. This may have been due, at least in part, to the governor's statement that money saved by closing the school could be used to supplement other veterans' benefits.[223] Robert Kauffman, representing Franklin County in the statehouse, proved to be the legislature's most outspoken defender of the school and continued to push for bills to save the school until the very end. But other local lawmakers, while generally supportive, took a more low-key approach and did not mount a vocal opposition to the closing. Despite a last-minute ray of hope in mid-July when House Democrats added an amendment to the governor's budget that would have restored much of Scotland's funding, SSVC students, faculty and staff never returned to the school after the close of the 2009 school year.

For Scotland supporters, the school's closure marked the end of an era and the loss of an important Pennsylvania institution—one with a proud history of supporting veterans' children. For the Scotland family, it was personal and, for many, deeply painful. Faculty, staff and students at the school in 2009 dealt with the most immediate ramifications. They had to vacate the campus, find new schools and jobs and adjust to vastly different circumstances. In some cases, students returned to homes, schools or communities that lacked Scotland's safety, stability and academic opportunities. Many teachers and coaches, some with decades of experience, had to establish themselves at

Fight for Survival

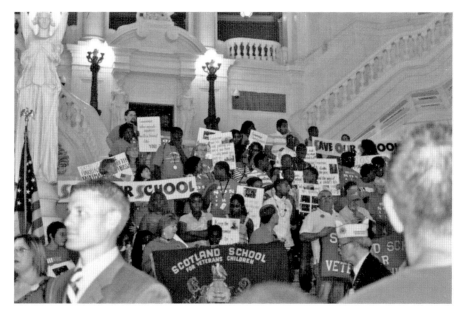

Scotland supporters rally in the state capitol building with Representative Rob Kauffman, June 2009.

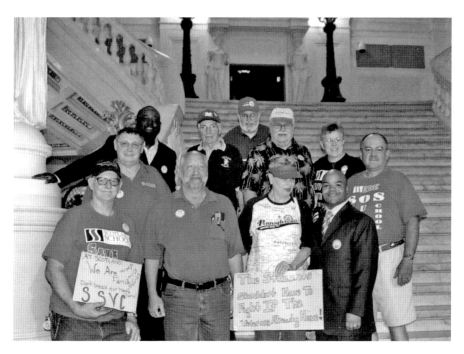

Alumni supporters at the state capitol, June 2009.

new schools. For many Scotland alumni, the closure kindled feelings of loss and sadness. For them, as for many generations before them, Scotland had been their childhood home—the place where they came of age and learned how to make their way in the world. And so, not wanting to let it go, they fought for Scotland's survival to the very end.

Epilogue

A small group of employees stayed on at Scotland through the summer and fall of 2009 to complete the process of closing the school. Ron Grandel retired and moved out of the superintendent's house later that year. Meanwhile, school supporters continued to lobby state legislators through the late summer and fall in the hope that funding might be restored and the school reopened the following year. They were temporarily encouraged by two pending house bills that included $7 million for SSVC, an inadequate sum but enough to "keep the doors open" as Jean Vargas, president of the Scotland Teachers' Association, said in a September 2009 interview for the *Patriot News*.[224] Despite these glimmers of hope, the Rendell administration remained firm in its decision to keep the school closed.

It is difficult to know where all 138 permanent salaried employees and 48 wage/temporary workers ended up after Scotland closed. In September 2009, Joan Nissley, spokeswoman for the Pennsylvania Department of Veterans and Military Affairs, provided some information on former employees to the *Patriot News*. According to her, 14 had been placed in other state agencies, 24 had retired and 88 had filed for unemployment. Nine people, including the superintendent, remained on the payroll as part of the school's transition team. Presumably, individuals not included in the numbers had found other employment. Most students returned to traditional public schools or charter schools in their home communities.

The Scotland property remained vacant until purchased in January 2013 by the Winebrenner Theological Seminary (Church of God) out of

Epilogue

Left to right: Frank Frame, Linda "Bupps" Sheaffer Price '69, Granville Waldt '41, Sally Sheaffer '65 and Bob Pierce (retired SSVC ROTC instructor) gather for a House hearing, August 4, 2009.

Findlay, Ohio, for $1.8 million. Relieved that the campus would no longer be vacant, local legislators and Scotland board members praised the sale as the best option forward for Scotland.[225] In addition to serving as a site for the seminary to hold classes and other programming, the campus currently houses several other groups as well. The former school gym is used as a fitness center open to the public, and other spaces on campus can be rented for weddings, conferences and retreats.[226] Recognizing the importance of SSVC history, the Winebrenner Theological Seminary (WTS) agreed to provide the Scotland School Alumni Association with a space on campus (the former laundry building) to house and maintain a school museum. Alumni volunteers, largely under the direction of Jim Lowe, who established the first SSVC museum in Cottage 3 in 1995, continue working on the building and displaying the museum collection. The alumni association maintains its website and Facebook page and continues to host alumni events at various community locations. Younger alumni also maintain close contact through social media and often hold SSVC gatherings in Philadelphia.

When the school closed, the Scotland School Foundation had a balance of approximately $469,000 in its account.[227] Foundation bylaws included procedures for dissolution, but it still took about three years to work through

that process and disburse the remaining funds, which could go only to nonprofit organizations. Although the SSVC Alumni Association would have benefited from using foundation money toward the museum effort, especially to make much-needed repairs on the building, the association did not have official 501(c)(3) status as a nonprofit organization. As a result, the foundation donated the balance of its funds to five other institutions: Chambersburg Area School District, Shippensburg University, Carson Long Military Academy, the Coalition of Residential Education and the University of Pittsburgh, with the stipulation that funds be used to support scholarships for SSVC graduates or individuals directly related to graduates or former employees or for individuals with a direct relationship to an honorably discharged veteran or active duty service person.[228]

Notes

CHAPTER 1

1. Speech by Governor Andrew Curtin to the Pennsylvania legislature, March 16, 1866, in James Laughery Paul's *Pennsylvania's Soldiers' Orphan Schools* (Harrisburg, PA: Lane S. Hart, 1877), 75.
2. For a full description of the system see Sarah Bair, "Making Good on a Promise: The Education of Civil War Orphans in Pennsylvania, 1863–1893," *History of Education Quarterly* 51, no. 4 (2011): 460–85.
3. *Annual Report, 1893*, 14. The annual reports by the Pennsylvania Soldiers' Orphans Commission for the period from 1889, when it was established, to 1918 and minutes from 1921 to 1923 are located in the Pennsylvania State Archives as part of RG19, Carton 5, Folder 1. Beginning on August 15, 1923, reports were issued by a board of trustees rather than the commission. These are located in folders by date in RG 19, Carton 5.
4. Ibid.
5. The decision to replace the state superintendent for Soldiers' Orphans with a Pennsylvania Soldiers' Orphans Commission in 1889 stemmed from a series of problems and scandals that challenged the system in the 1880s. For further discussion of the scandals see Bair, "Making Good on a Promise," 481–2.
6. *Annual Report, 1893*, 10.

7. Some portions of Scotland's early history first appeared in Sarah Bair, "Continuing to Pay the 'Patriotic Debt': The Establishment of the Pennsylvania Soldiers' Orphans Industrial School, 1893–1912," *Pennsylvania History: A Journal of Mid-Atlantic Studies* 82, no. 4 (2015): 460–88.
8. *Annual Report, 1894*, 8.
9. See *Reveille to Taps, Yearbook for the Class of 1937* and "100th Anniversary of SSVC," a speech given to the Kittochtinny Historical Society to mark the 100th anniversary of the school in June 1995, no author listed, Scotland Museum.
10. "100th Anniversary of SSVC."
11. *Annual Report, 1896*, 79.
12. *Annual Report, 1897*, 103–6.
13. *Industrial School News* 6, no. 2 (November, 21, 1901): 3. School newspapers from 1897 to 1970 (thirty-seven volumes) are located in the Pennsylvania State Archives as part of Record Group 19.
14. *Annual Report, 1901*, 104.
15. Ibid.
16. *Annual Report, 1899*, 120–21.
17. *Annual Report, 1901*, 3.
18. Board minutes, May 17, 1924.
19. *Industrial School News* 22, no. 9 (January 1918): 2.
20. *Annual Report, 1918*, 6.
21. Ibid., 5.
22. Commission minutes, June 21, 1921.
23. In the summer of 1923, Scotland came under the control of the Pennsylvania Department of Public Instruction. The Pennsylvania Soldiers' Orphan Schools Commission was disbanded and replaced by a board of trustees. The new board met for the first time on August 15, 1923.
24. 1930 Bulletin of Information, 23, Scotland Museum.
25. *Courier* 56, no. 6 (April 16, 1953): 1.
26. Ray McKenzie, interview by author, June 4, 2015.
27. Anne Elder Imperial, conversation with author, June 10, 2015.
28. Donald Cooper, *SSVC One Hundred Year Retrospective, 1895–1995* (Scotland, PA: 100th Anniversary Committee, 1995), 84.
29. Ibid., 104.
30. Ibid., 87–88.

Chapter 2

31. Sanner scrapbook, Scotland Museum.
32. Some portions of chapters 2 and 3 focusing on students' experiences at the school first appeared in Sarah Bair, "'This Place Was My Home': Student Reflections on Living at the Scotland School for Veterans' Children (1930–2009)" *Pennsylvania History: A Journal of Mid-Atlantic Studies* 83, no. 4 (2016): 502–28.
33. This assessment is based on oral history interviews conducted by the author, on interviewees' descriptions of fellow alumni and on informal conversations with alumni and former staff.
34. Mary Pat Flaherty, "Free Education for Veterans' Needy Children," *Pittsburgh Press*, January 7, 1983, 18A.
35. Kristin B. Ellis, "More May Qualify for Scotland School," *Public Opinion*, September 28, 1994, 3A.
36. George Ramsden, interview by author, June 12, 2009.
37. Andrew Hobby, interview by author, June 12, 2009.
38. George Hockenberry, interview by author, June 12, 2009.
39. Granville Waldt, interview by author, June 12, 2009.
40. Tedd Cocker, interview by author, June 13, 2009.
41. Shirley Kennedy Gochenour, interview by author, June 12, 2009.
42. Lisa Edwards, interview by author, June 12, 2009.
43. Michael Mack, interview by author, June 13, 2009.
44. Bill Smoker, interview by author, June 12, 2009.
45. Kevin Tucker, interview by author, June 13, 2009.
46. Frank Frame, interview by the author, June, 2, 2015.
47. Gochenour, interview.
48. Agnes Gorman Harris, interview by author, June 12, 2009.
49. Tucker, interview.
50. Margaret Helm Mowry, interview by author, June 12, 2009.
51. Nancy Wright, interview by author, June 18, 2016.
52. Smoker, interview.
53. Taajudeen Cousin, interview by author, June 13, 2009.
54. Connie Mull, "House Parents Fear for Safety," *News Chronicle*, November 25, 1991, 1–2.
55. Frame, interview.
56. The person who made this statement is the brother of Bill Smoker and Connie Smoker Eells. He also attended the school and was present during their June 12, 2009 interview.

57. Donna Sutton, interview by author, June 13, 2009.
58. Randy Gates, conversation with author, June 12, 2015.
59. Ramsden, interview.

Chapter 3

60. Board minutes, January 10, 1925.
61. Board minutes, November 19, 1932.
62. Ramsden, interview.
63. Edie Mixell, interview by author, fall 2009.
64. 1936 Pennsylvania Soldiers' Orphan School Guide, Scotland Museum.
65. Mowry, interview.
66. "House Parents Fear for Safety," 1–2.
67. For analysis of the pervasive use of corporal punishment in homes and schools see Philip Green, *Spare the Child: The Religious Roots of Punishment and the Psychological Impact of Physical Abuse* (New York: Alfred A. Knopf, 1991); Irwin A. Hyman and James H. Wise, eds. *Corporal Punishment in American Education: Readings in History, Practice, and Alternatives* (Philadelphia: Temple University Press, 1979).
68. Edwards, interview.
69. Ramsden, interview.
70. Regis Buckwalter, interview by author, June 13, 2009.
71. Frank Gorman, interview by author, June 12, 2009.
72. Tucker, interview.
73. Board minutes, May 3, 1952.
74. Name withheld, interview by author, June 13, 2009.
75. Richard Brobeck, interview by author, June 13, 2009.
76. Ray McKenzie, interview by author, June 4, 2015; Kaye Shearer, interview by author, June 4, 2015.
77. Taajudeen Cousin, Michael Mack and Kisha Bridges, interview by author, June 13, 2009; Matthew Haberle, interview by author, June 18, 2016; Harriet Leon, interview by author, June 18, 2016.
78. Frame, interview.
79. Mack, interview.
80. Sally Sheaffer, conversation with author, June, 9, 2015.
81. Shearer, interview.
82. 1936 Pennsylvania Soldiers' Orphan School Guide.

83. Cousin, interview.
84. Leon, interview.
85. Connie Smoker Eells, interview by author, June 12, 2009.
86. Buckwalter, interview.
87. Cocker, interview.
88. Hockenberry, interview.
89. Mowry, interview.
90. Harris, interview.
91. Cocker, interview.
92. Eells, interview.
93. Granville Waldt, Andrew Hobby, George Ramsden, Bill Smoker and George Hockenberry, interviews by author. Although farm operations cut back in the 1960s, the school continued to maintain a hog operation for several more years.
94. Randy Bower Sr., interview by author, June 13, 2009.
95. Hockenberry, interview.
96. Tara Nicole Smith, e-mail message to author, June 21, 2016.
97. Frame, interview.
98. Memo prepared for Frank Frame dated February 25, 1991, Special Info SSVC 1991, Crisis Binder, Scotland Museum.

Chapter 4

99. Eells, interview.
100. Carl L. Bankston III and Stephen J. Caldas, *Public Education America's Civil Religion: A Social History* (New York: Teachers College Press, 2009), 27–34; Henry J. Perkinson, *Imperfect Panacea: American Faith in Education, 1865–1965* (New York: McGraw Hill, 1968), 10–12.
101. *Annual Report, 1899*, 111.
102. 1930 Bulletin of Information, 27, Scotland Museum.
103. 1928–29 Bulletin of Information, 47, Scotland Museum.
104. *Annual Report, 1896*, 97.
105. Board minutes, September 27, 1924.
106. Board minutes, February 4, 1928.
107. 1936 Handbook, 18, Scotland Museum.
108. Ibid., 27–28.
109. *Courier* 32, no. 5 (March 8, 1928): 1.

110. *Courier* 42, no. 3 (March 10, 1938): 1.
111. *Courier* 42, no. 8, (October 13, 1938): 1.
112. Board minutes, March 31, 1933.
113. *Taps*, 1953, all yearbooks located in Scotland Museum.
114. Board minutes, August 8, 1932.
115. *Courier* 70, no. 1 (October 1967): 1–2.
116. For an excellent overview and pictures of the labs see Winifred Scheffler, "A Place to Live and Learn," *American Education* 17, no. 3 (1981): 16–21.
117. SSVC math lab pamphlet, undated, Scotland Museum.
118. Scheffler, "Place to Live and Learn," 16.
119. SSVC math lab pamphlet.
120. Bridges, interview.
121. Cousin, interview.
122. For more on the various approaches to industrial education see Sarah Bair, "Continuing to Pay the 'Patriotic Debt," 476–78.
123. *Annual Report, 1896*, 5.
124. Ibid.
125. *Annual Report, 1904*, 6.
126. *Industrial School News* 6, no. 1 (February 14, 1901): 3; ibid., 6, no. 15 (May 8, 1902: 3; 10, no. 2 (September 28, 1905): 3.
127. 1928–29 Bulletin of Information, 21–22.
128. *Industrial School News* 6, no. 1 (February 14, 1901): 3.
129. *Taps*, 1950.
130. Board minutes, January 20, 1941.
131. Board minutes, July 26, 1940.
132. *Courier* 47, no. 1 (September 24, 1942): 2.
133. *Taps*, 1998.
134. Board minutes, April 26, 1941.
135. Buckwalter, interview.
136. Gochenour, interview.
137. Sonia Williams, e-mail message to author, July 6, 2016.
138. For a good overview of the trades, see Charles Goldstrohm *Seventy-Fifth Anniversary Retrospective, 1895–1970* (Scotland, PA: 75th Anniversary Committee) and Donald Cooper, *SSVC One Hundred Year Retrospective*.
139. Waldt, interview.
140. David Shaw, interview by author, June 13, 2009.
141. Hockenberry, interview.
142. *Taps*, 1998.
143. *Taps*, 2000; *Taps*, 2001.

144. *Taps*, 2002; Frame, interview.
145. Shearer, interview.
146. Ibid.
147. For details on camp activities, see two outdoor education scrapbooks containing photographs, daily schedules, pamphlets and newspaper accounts, Scotland Museum.
148. *Courier* 81, no. 4 (March 1976): 1.
149. McKenzie, interview.
150. Shearer, interview.
151. Ibid.
152. Gerald Wilson, interview by author, June 16, 2016.
153. *Annual Report, 1899*, 112.
154. *Annual Report, 1911*, 58.
155. James Lowe, interview by author, June 3, 2016.
156. Frank Frame, conversation with author, July 19, 2016.
157. *Taps*, 1950.
158. 1936 Handbook, 24–25.
159. *Taps*, 1943.
160. Mixell, interview.
161. Gorman, interview.
162. Lowe, interview.
163. Leon, interview.
164. John Chontos, conversation with author, May 27, 2016.
165. Don Engle and Dave Frey, conversation with author, May 27, 2016; Dave Frey, e-mail message to author, July 4, 2016.

Chapter 5

166. Wilson, interview.
167. Larry McSeed, interview by author, July 12, 2016.
168. Smith, e-mail.
169. Ibid.
170. McSeed, interview.
171. Haberle, interview.
172. Frey, e-mail.
173. Ibid.
174. Smith, e-mail.

175. *Industrial School News* 2, no. 4 (March 25, 1897): 3; ibid., 6, no. 11 (March 13, 1902): 1.
176. Goldstrohm, *Seventy-Fifth Anniversary Retrospective*.
177. *Annual Report, 1903*, 92–94.
178. Gochenour, interview.
179. Sheaffer, interview.
180. Patrick McNamee, e-mail message to author, June 16, 2016.
181. Ibid.
182. Cooper, *SSVC One Hundred Year Retrospective*, 69.
183. S Club constitution, 1936, Scotland Museum.
184. Williams, e-mail.
185. *Industrial School News* 2, no. 5 (April 8, 1897): 3.
186. *Industrial School News* 2, no. 7 (May 6, 1897): 4.
187. PIAA Boys Track and Field Championships (1925–2011), http://www.rodfrisco.com/wp-content/uploads/2010/08/PIAA-BOYS-TRACK-REX-ALL-TIME.pdf.
188. *Taps*, 2001.
189. *Courier* 37, no. 6 (March 16, 1933): 1.
190. *Annual Report, 1898*, 116–17.
191. *Pennsylvania Soldiers' Orphan School Guide*, 1936.
192. Ibid.
193. *Industrial School News* 22, no. 20 (June 1918): 4.
194. *Courier* 42, no. 4 (April 14, 1938): 4.
195. Sheaffer, interview.
196. Lowe, interview.
197. *Courier*, 37, no. 18 (November 9, 1933): 3.
198. Diane Bowen, e-mail message to author, June 19, 2016.
199. "6000 Kids of Vets Call This Alma Mater 'Home,'" *Navy Times*, July 30, 1960, 14–15.
200. Lowe, interview.
201. "6000 Kids of Vets Call this Alma Mater 'Home,'" 14–15.
202. Haberle, interview.

Chapter 6

203. Hundreds of documents related to the 1991 closing are located in the Scotland Museum in a series of binders labeled numerically 1–8 with one

additional binder labeled "Crisis." This document can be found in the Crisis Binder.
204. "Information Pertaining to Scotland School for Veterans' Children: A Rebuttal to the Pennsylvania Department of Education," Crisis Binder.
205. Sue Saylor, to Frank Frame, memo, February 1991, Crisis Binder.
206. Frame, interview; Donald Carroll, memo to "interested parties," March 25, 1991, Binder 5.
207. Slides available in Crisis Binder.
208. Frame, letter and enclosures to members of Basic Education Subcommittee, May 7, 1991, Crisis Binder.
209. Copies of these letters can be found in Binder 3.
210. Press release from Pennsylvania War Veterans' Council, May 15, 1991, Binder 6.
211. Sue Saylor, "Organizational Donations to SSVC Special Funds for Fiscal Years 1988–89 and 1989–90," memo to Frank Frame, February 25, 1991, Crisis Binder.
212. Frame, interview.
213. *Taps*, 1992.
214. Testimony given by Frank Frame at April 30, 1991 legislative hearing describing the revised budget proposals.
215. *Scotland Sentinel*, a publication of the foundation for SSVC, August 2005, 2005–present Foundation Binder.
216. Vicky Taylor, "Parents Gather at SSVC," *Public Opinion*, February 16, 2009.
217. Grandel, letter to SSVC parents, February 18, 2009, 2009 Closing Binder.
218. Vicky Taylor, "Department of Education Claim about Students at Scotland School for Veterans' Children Irks School Supporters," *Public Opinion*, April 26, 2009.
219. Gail Schuyler, "State Efforts Not What It Claims," *Public Opinion*, May 18, 2009.
220. Lara Brenckle, "Faculty, Students Prepare to Move On," *Patriot News*, June 12, 2009.
221. Roscoe Barnes III, "Study Touts SSVC's Role in Economy," *Public Opinion*, March 24, 2009.
222. FCADC, letter to Alloway, May 5, 2009, 2009 Closing Binder.
223. Lara Brenckle, "Fate of Scotland School for Veterans' Children Remains Unsure," *Patriot News*, September 14, 2009.

Epilogue

224. Ibid.
225. Roxanne Miller, "Seminary Buys Former Scotland School for Veterans' Children," *Herald-Mail.com*, January 26, 2013.
226. See Winebrenner Theological Seminary, Scotland Campus website at http://www.scotlandcampus.com/.
227. Frame, interview; foundation financial records provided by Frame.
228. Frame, interview; Distribution of Assets agreements, Foundation Binder, Scotland Museum.

Index

A

academic support 84–85
 labs 84
Act of 1893 20, 22
admissions, criteria 46, 125, 126
Allen, John G. 30, 31, 35, 82, 88, 91
athletics 39, 104, 108–115
 boys' basketball 111–112
 boys' track 39, 110–111
 coaches 102, 104
 football 112, 114
 girls' basketball 111
 girls' track 111

B

Bambrick, William C. 28
Bard, Joseph 124, 125

C

Calverase, Francis J. 38, 39, 63, 124
Camp Legion 34, 59, 93, 94, 100
Carroll, Donald 124, 125
Casey, Robert P. 114, 123, 124, 125, 126
Chester Springs 21, 23, 27, 28, 87, 130
Clark, James M. 23
closing 39, 133–138
cottages 21, 31, 36, 53
 honor suites 132
Coy, Jeffrey, PA State Rep. 129, 130
crisis of 1991 39, 124–130
curriculum 31, 82–98
 academic 82–86
 industrial 86–92
 moral 95–98
Curtin, Andrew G. 19, 46

D

demographics 125, 126, 128
 change in geographic area 45
 increase in African American students 45
discipline 62–67
 class system 63

Index

corporal punishment 48, 63–66, 67
 gender 67
 merit/demerit system 63
 order 62, 71
 race 66
 work as form of 63

E

enrollment 28, 38, 39, 126, 127, 132
Evans, Dwight, PA State Senator 129
experiential learning 92–95
 field trips 92–93
 outdoor education 93–95
extracurricular activities 101–107
 Boy Scouts 118
 Curtin Literary Society 116
 music 104–105, 106–108
 newspaper 116
 theater 105, 116
 visiting other schools 105
 yearbook 117

F

farm 29
fire of 1901 25
fire of 1951 35
Foundation for Scotland School 123, 124, 132, 140
 Boozer Hall 132
 John E. McAllister Golf Tournament 133
 Student Quality of Life Endowment Fund 133
 Tree of Lights 133
 Triad Strategies 134, 135
Frame, Frank C. 37, 39, 57, 93, 123, 124, 126, 127, 128, 129, 130, 131, 132, 134, 135

G

Grandel, Ronald 134, 139
guidance department 84

H

Harford 21, 26, 87
Heckler, James R. 37
Heckler, Maurice "Cap" 35, 63, 65, 66
house parents 54–57

J

Jannuzi, John E. 37, 38
JROTC 38, 39, 67, 69, 93, 104, 130

K

Katusin, Kenneth 84, 112, 128
Kauffman, Robert, Pennsylvania state representative 136

L

leisure activities 117–121

M

Magee, Frank G. 23
military training 67–71

P

Pennsylvania Soldiers' Orphans Industrial School (SOIS) 20
 admissions requirements 20–21
 daily schedule 25–26
 founding of 20
 mission of 20, 46
Pennsylvania Soldiers' Orphans School (SOS), name change 31
Punt, Terry, Pennsylvania state senator 114, 124, 130

Index

R

Raider team 69
Red Blazer Club 132
Reinecker, Dale H. 37, 38, 39, 54
religion 95–98
Rendell, Edward G. 133, 134, 136, 139

S

Scotland School for Veterans' Children (SSVC), name change 35
Shippensburg University 83, 84, 85, 93, 123, 141
Signor, George C. 28, 29, 30
Skinner, George W. 25, 26
Smathers, C. Blaine 30, 31, 35, 61, 62, 63, 71, 82, 83, 88, 91, 116
Stevens, Willard M. 36
Stewart, Jerry 123, 127, 128, 131
Stewart, William H. 25, 28
students
 arrival at school 52–54
 bond with one another 57–59
 decision to enroll 49–52
 family circumstances 46, 51–52

T

teachers 83, 98–100, 129
Thounhurst, M.L. 23
Title I funding 39, 84, 93

U

Uniontown 21, 27, 87

V

veterans' organizations 75–79, 129

W

Winebrenner Theological Seminary 139
work detail 72–75
World War I 28
World War II 31–33

Y

Young, Charles L. 23

Z

Zahorchak, Gerald 134

About the Author

Sarah Bair is currently an associate professor of educational studies at Dickinson College in Carlisle, Pennsylvania. She earned her bachelor's degree in history from Albright College, her master's in history from Shippensburg University and her PhD in curriculum and instruction from the Pennsylvania State University. She resides in Gettysburg with her husband and youngest daughter. They also have two adult children.

Visit us at
www.historypress.net
..
This title is also available as an e-book